THE MAKING OF

RED RUM

The Sculptor's Story

PHILIP BLACKER

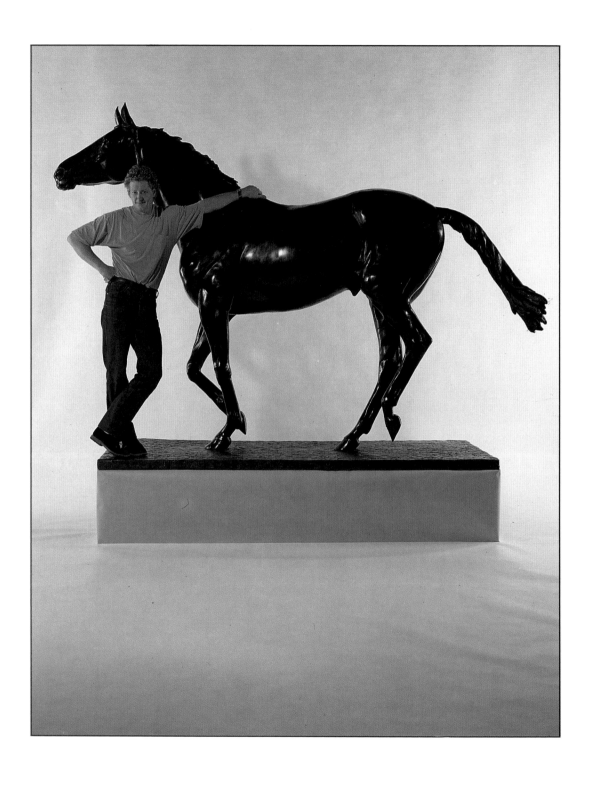

THE MAKING OF
RED RUM

The Sculptor's Story

PHILIP BLACKER

PARTRIDGE PRESS

Designed by Graeme Murdoch
Edited by Alison Goldingham

TRANSWORLD PUBLISHERS LTD
61–63 Uxbridge Road, London W5 5SA

TRANSWORLD PUBLISHERS (AUSTRALIA) PTY LTD
15–23 Helles Avenue, Moorebank NSW 2170

TRANSWORLD PUBLISHERS (NZ) LTD
Cnr Moselle and Waipareira Aves,
Henderson, Auckland

Published 1988 by Partridge Press,
a division of Transworld Publishers Ltd
Copyright © Philip Blacker 1988

British Library Cataloguing in Publication Data

Blacker, Philip
 The making of Red Rum: the sculptor's story.
 1. English sculptures. Blacker, Philip.
 Special subjects. Steeplechasing horses.
 Red Rum
 I. Title
 730'.92'4

ISBN 1-85225-061-5

Printed in Great Britain by
Jolly & Barber Ltd, Rugby

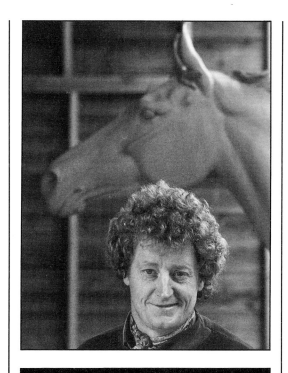

CONTENTS

Acknowledgements
Bumble Upton, for typing the manuscript
and making pertinent comments
Paul Cowan, for the idea
Gerry Cranham, for the photography

Dedication
For "The Fount"

Introduction
by Major Ivan Straker

WHEN JOHN HUGHES and I were discussing how best to mark the 150th running of the Grand National at Aintree, little did I envisage the importance of the final outcome. What I did know was that the Grand National was the greatest steeplechase in the world and that the incomparable Red Rum had carved his name into the annals of the race for all time. Famous names like Manifesto, Sergeant Murphy, Golden Miller and Reynoldstown roll off the tongue as one thinks back into the past but none succeeded in stamping their name on the race quite like Red Rum did in those glorious five years from 1973 to 1978. Three wins and two seconds have never been surpassed nor do I believe they ever will be. Red Rum epitomised the essential qualities required by a horse if he or she is to stand a chance of winning this great race in a normal year. Courage, plain love of jumping, the agility of a cat, a relentless galloper coupled with endurance and an almost human will to win, were the supreme qualities with which the great Red Rum was blessed.

It was with this in mind that John Hughes and I felt that future generations of National Hunt lovers should have a permanent reminder of Red Rum's unique record: a life-sized statue of the great horse set in the surrounds of Aintree at a point where it could be seen and admired by the maximum number of racegoers. This idea was wholeheartedly endorsed by The Seagram Company whose generosity had already helped to save both Aintree and The Grand National. Although at the time I had not met Philip Blacker, his name was well known to me, both as a professional National Hunt jockey and as a sculptor. John Hughes, and others, whose advice I sought, left me in no doubt that Philip Blacker was the man to undertake this important commission. Philip was born into the saddle. He

rode to hounds at the age of three. His knowledge of horses and their idiosyncrasies is as good as anyone I know. His career as a professional jockey spanned some thirteen years during which time he rode a total of 329 winners. Whilst he may not have been lucky enough to ride Red Rum, he did ride a number of other outstanding chasers including Spanish Steps and Royal Mail. He was first jockey to Stan Mellor for five years and rode regularly for a number of other leading trainers including his great friend John Edwards. When asked whether he would like to do the commission, his expression said it all. His outright enthusiasm and excitement were so obvious that we knew we had made the right choice.

This book is three stories in one, each equally fascinating. The story of Blacker the jockey, with all the ups and downs any top class National Hunt jockey seems to go through; the story of Blacker the artist with all the problems of starting a second career and, finally, the technical story of how he sculptured the life-sized statue of the greatest horse, Red Rum, ever to gallop over the Aintree turf.

Philip's success lies in his hands and eyes. It was his hands on the reins and his visual judgement of a fence that won his owners and trainers so many races. It is his hands and his visual appreciation of the subject that make him one of the great living British sculptors. It is by his hand that this delightful, interesting and entertaining book is written. I have no doubt that when, on 9th April 1988, his sculpture of Red Rum is unveiled we will all once again acclaim the work of those hands.

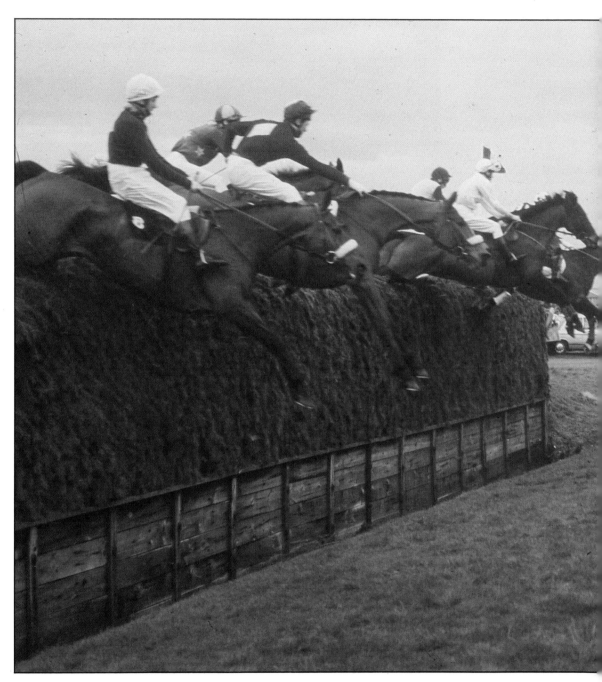

The 1973 Grand National and the field jumps Bechers for the first time. In the foreground Red Rum jumps upsides stable companion Glenkiln. Spanish Steps and I are obscured except for my yellow cap just showing behind Brian Fletcher's bac

Chapter One

AN HISTORIC RACE

FOR A SECOND I eased my grip on the reins to allow Spanish Steps full power over the next couple of furlongs. The horse's response was all I could have hoped for – he was spot-on. I pulled up and dismounted with a growing feeling of confidence.

The time was 7.30 a.m. on the morning of the 1973 Grand National. The place was Aintree Racecourse. All around the collecting area were small knots of pressmen, trainers, jockeys and owners huddled together, talking in subdued tones. Every few minutes a runner would emerge onto the track from the racecourse stables, creating renewed interest amongst the spectators. This was my third taste as a professional jockey of the pre-Grand National build-up. My two previous rides in the race had been on Vichysoise, a horse of some ability but precious little courage. He had distinguished himself on his pre-Grand National warm-up race at Ludlow, the course with probably the smallest fences in the country, by trying to refuse at the first in the back straight. I was consequently amazed to find that he took to the big Aintree fences as if he had been waiting for them all his life and he finished a creditable sixth after being badly hampered at the Chair fence. However, that sparkling performance was not repeated the following year: on returning to Aintree he put in a thoroughly mulish performance on the first circuit and, when asked to do another one, refused point-blank.

Now, in 1973, I was aware that, for the first time, I had a real chance of winning. Instead of feeling more nervous as a result, my faith in my horse grew as the race approached. The reason for this was obvious – Spanish Steps exuded class and ability. Unfortunately the handicapper was of the same opinion and we were allotted second-top weight of 11st 13lb.

Within a short time Spanish Steps had established himself as one of the top-class horses of his generation, winning most of the big chases and only being denied the Cheltenham Gold Cup. Tragically when he was anti-post favourite and at the peak of his powers, a mix-up concerning the four-day declarations unintentionally rendered him a non-runner. Now, at the age of ten, he was having his first crack at the National. Although still in the top league, he was considered to have just lost the edge of his pace and so was no longer a serious Cheltenham Gold Cup contender, however, he

was at an ideal stage in his career to tackle the gruelling four and a half miles of the National.

Only that season I had secured the retainer riding for Edward Courage. This was regarded as a prestigious job. The small but highly successful stable was held in high esteem, mainly due to the two stable stars, Spanish Steps and Royal Relief, another brilliant performer. My association with Spanish Steps was, like my career in general, not without its hiccups. Happily my debut for the Courage stable and on the great horse could not have got off to a better start when we won, with ease, the Hermitage Chase at Newbury. Never before had I ridden a horse of his calibre on a racecourse and for the first time I experienced much more than just the co-ordinated power and balance that every top-class horse possesses. I also discovered a sensation that would occur only too rarely during my career, that of sheer dominance over the opposition.

Following the Hermitage came the Mackeson Gold Cup at Cheltenham, for which we were now a short-priced favourite. That day I had three rides booked, the first of which was before the Mackeson on a rather unreliable novice chaser whose jumping left a lot to be desired. In the weighing-room Tommy Stack approached me and advised, "Hey, you must be a lunatic riding that novice chaser before the Mackeson. He's got no chance!" "I need the money", I replied, smiling cheerfully. His sound observation was thus laughed off with great bravado, but I knew that taking the risk of getting injured before the big race was foolhardy. In the event, the novice chaser survived several appalling blunders before finally burying me at the last, when out of contention. My immediate reaction on picking myself up was one of relief that I appeared to be all in one piece, apart from a seemingly minor pain in my wrist. Walking back to the weighing-room, I came across a worried-looking Edward Courage and assured him that all was well. However, there was another race to go before the big one and by the time it was over my wrist had begun to hurt quite badly. I went to the ambulance room to get it strapped up, but I had convinced myself there was nothing seriously wrong and that I would forget the pain in the heat of the race. Out in the paddock I was legged-up onto the horse and then I knew we were in trouble. As I went to grip the reins, my fingers completely seized up. It was far too late for a jockey change, so I knew I had to go through with the ride. My hand was locked onto the reins and throughout the entire race I never changed grip. It was run at a highly competitive pace and during the closing stages I was virtually immobile. Whether we would have won without my handicap I rather doubt, but we certainly would have finished much closer. As it was, we came in fourth, and I was

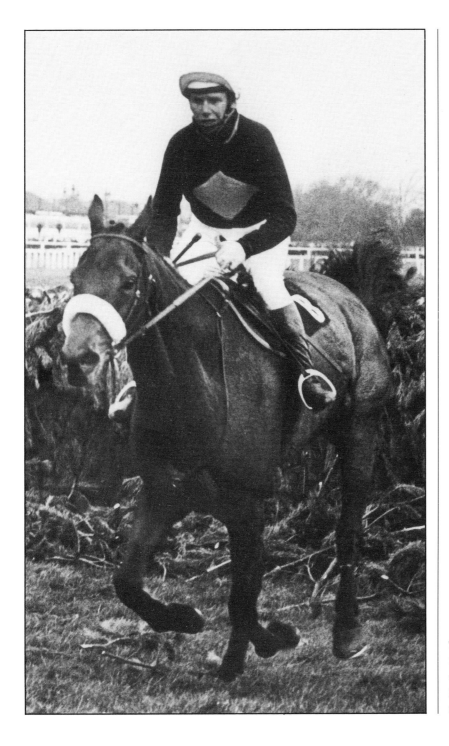

The last fence of the
1973 Grand National
with Red Rum in
hot pursuit of
the tiring Crisp.

Spanish Steps and I jump Bechers second time round in third place. Just out of shot Red Rum has started to draw away from us and close the gap on Crisp.

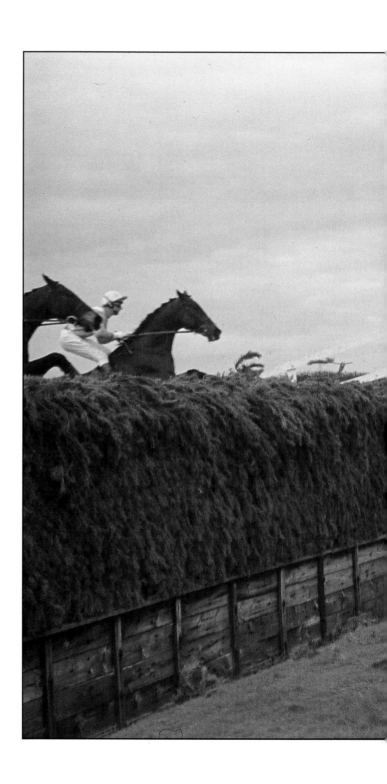

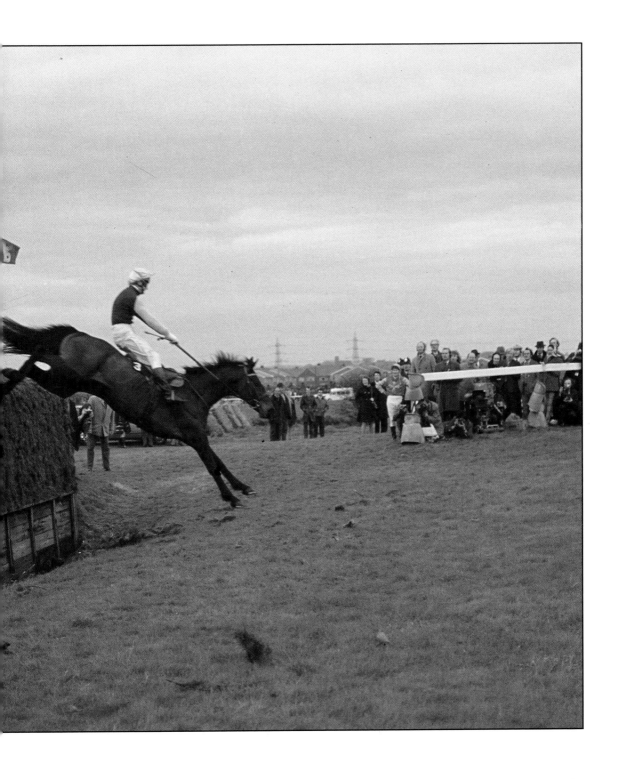

suffering serious pain. I immediately cancelled my final ride of the day and went to hospital, where a fractured wrist was diagnosed. It was a month before I was back in action again. The rest of the season brought us a run of seconds which, although infuriating, confirmed the horse's well-being and his need for a longer distance.

With the morning exercise at Aintree Racecourse concluded satisfactorily, I returned to my hotel in Southport to enjoy a treat which I was rarely permitted – a hearty breakfast. Carrying second-top weight did have one advantage in that I could eat. Being 5ft 11ins tall, weight had been a constant battle throughout my career, but that morning, at least, I was not going to worry. Over a hearty supply of bacon and eggs we read the papers and discussed our chances. Joint top weights, and carrying one pound more than us were the Australian horse, Crisp, and the Irish horse, L'Escargot: Crisp was a tall, rangy individual with an impressive record, but he was generally considered to be at his best over $2\frac{1}{2}$ miles and so there were doubts about his stamina; L'Escargot was an obvious danger, having won the Gold Cup in 1970 and 1971. There was also a much-fancied, locally trained horse called Red Rum. He had come to Aintree with a highly successful campaign under his belt, having won his first five outings of the season. Although he had been running in the north all season and had not been up against very testing competition, his consistency and handy weight of 10st 5lb ensured that he had plenty of supporters. He was to be ridden by Brian Fletcher, an acknowledged Aintree specialist who had already won the Grand National on Red Alligator in 1968. On paper the 1973 Grand National looked to be the most competitive in years, and so it was to prove.

Traditionally, on the morning of the National, many jockeys head off for the turkish baths in Southport to lose the last few pounds. Lightweight jockeys rarely frequent the baths but being one of the heavier variety I used to spend many an excruciating hour sweating with the same hardcore of fellow unfortunates. Luckily on this memorable occasion weight was not a problem, so I was able to afford another rare luxury of going to the baths and enjoying the inevitable glass of champagne and the convivial atmosphere without having to worry seriously about losing weight.

There is a popular theory amongst jockeys that a glass or two of champagne consumed whilst in the baths opens the pores and therefore aids the sweating process. At first, I was only too pleased to go along with this myth and for a while I even believed it, until one day, having imbibed rather too enthusiastically, I emerged from the baths two pounds heavier than when I went in!

In the jockeys' changing-room at Aintree, my friend John Buckingham, the jockeys' valet, was as usual managing to diffuse any tension with an endless stream of jokes. The title, jockeys' valet, implies a certain lowly status in life and belies the true nature and importance of the job. John had pursued a successful career as a jockey, winning the Grand National in 1967 on Foinavon and so was perfectly qualified for the job. A valet has to maintain in perfect condition the endless pieces of a jockey's equipment, from his saddles, breastplates, girths, etc. right down to the ladies' tights worn under the thin breeches for lightness and warmth. He also has to transport the equipment from racecourse to racecourse, every day producing it in complete and sparkling condition. Additionally, he has to contend with the jubilation, despair, irritation, depression and every other extreme of emotion brought about by circumstances taking place outside his vision. He has to remain smiling and encouraging throughout and ensure that maybe twenty jockeys go out to ride with the correct weight and equipment. For some curious reason, jockeys often behave in a different manner before the Grand National than before any other race. The normally talkative ones become dumbstruck, whilst the quiet ones assume an air of jocularity that would convince anyone that they did not have a care in the world. I was dubbed the "box-walker" because of my tendency to pace up and down in front of my pitch whilst changing. I found myself doing this subconsciously until John brought me back to earth with a wry, "Blacker must be fancied today – he's walking his box again!"

Out in the paddock the Courages discussed last-minute tactics with me. There are several schools of thought about the ideal course to take round Aintree. Several exponents reckon that the best is the shortest route, down the inside, taking the fences where the drop on the landing side is at its severest. Others hold the opposite viewpoint and sacrifice the short way for more room and easier fences. At this point in my career I had yet to form any strong opinion and after much debate we decided to compromise by going down the middle. In later years, I became firmly convinced that as long as the horse was a good jumper, the inside berth was preferable but the enormous amount of ground saved by this route is not immediately apparent until it has been taken.

Spanish Steps was a good jumper but he was bold and impetuous and this was a slight worry. He tended to attack his fences with real gusto, standing right back on take-off whenever possible. If we were to survive the Aintree fences, I had to try to dissuade him from any extravagant leaps in the early stages, as this would be disastrous. The sight of those fences could have the effect of making him even braver than usual, in which case

we would not last long. Alternatively, as I hoped, they might have the opposite, sobering effect on him. Contrary to popular belief, the ideal National horse is not always the one with limitless courage. It often happens that a horse who is "a bit of a thinker" really takes to Aintree, certainly the first time the animal takes part. Of course the novelty and occasion set the adrenalin flowing in those who need courage, but at the same time they still retain a strong instinct for self-preservation which is essential for survival. Very often, as in the case of Vichysoise, the magic works once but never again. The truly brave horses are the ones who go back time and again and put up a consistent performance.

With a huge roar from the crowd the tapes went up and the thirty-eight runners for the 1973 Grand National surged forward and headed off towards the Melling Road. In front of us the first six fences stretched out, green and inviting. From here you could not see the big drops on the landing side, gradually increasing in severity until Bechers is reached at the end of the line. Half-way to the first it was very clear that this was no ordinary Grand National gallop. Every year the field thunders down to the first at a seemingly break-neck speed in order to keep out of trouble, but this time we really were travelling. Everywhere jockeys were jostling for positions to get a clear run at the fence.

The field fanned out across the course and twenty yards from the fence I could see we had a clear run, so I checked Spanish Steps in his stride to prevent him from over-jumping. I need not have worried. He registered the size of the big fences and took off with care and precision. Others were not so lucky. Amidst the pounding of hooves and flying gorse, a splintering crash nearby heralded the end of the race for Neil Kernick and Richlieu as they breasted the fence and nose-dived to the ground. Landing safely over the second fence I realised we were lying more or less where we wanted to be, midfield. However, the gallop was much stronger than I had wished. I had fully expected to hunt round for the first circuit, but the unusually fast pace was making it impossible.

Out in front of the field I could just see, on the inside, the dark shape of Crisp and Grey Sombrero across the course from him, with Bill Shoemark aboard. With every stride and each jump, these two were drawing further away from us. At the third fence, the fourteen-to-one shot, Ashville, came to grief, but Spanish Steps was still jumping well. By the time we got down to Bechers on the first circuit Grey Sombrero and Crisp were well clear of the rest of the field. I was convinced that they were cutting each other's throats and that they would eventually come back to us, but I could not afford to let them get too far in front. Spanish Steps, I knew, would stay,

Brian Fletcher was Red Rum's successful partner for the first two of his three Grand National victories.

but whether he could last out at that pace was another matter. At Bechers the headstrong Grey Sombrero blundered, allowing Crisp to go into a clear lead, with the Irish horse, Black Secret, in third place, but beginning to weaken. The furious pace was already beginning to tell on some runners and they began to crack and drop back. We jumped the Canal Turn in eleventh position and headed for home for the first time. This was not how I had anticipated the race. With only half the first circuit completed, we were struggling. The only small consolation was that everyone else seemed to be in the same predicament, except for those two out in front.

I started to thread my way through the field and improve our position, but Crisp and Grey Sombrero increased their lead. Crossing the Melling Road and back on the racecourse, out of the corner of my eye I saw a

classy-looking individual approaching my girth and slowly making ground on me. As he came upsides I recognised the grim features of his jockey, Brian Fletcher. Although not exactly with a double-handful, he was nevertheless going rather better than we were. It was thus as we approached the largest fence on the course, the fearsome Chair fence, that I caught my first glimpse of Red Rum. A few seconds later, out in front of us, Grey Sombrero crashed horrendously at the big open ditch, suffering fatal injuries. Heading out on the second circuit, Spanish Steps and Red Rum were at the front of the field, in pursuit of Crisp, who was bounding his fences and making so much ground getting away from them that he was still increasing his lead. For the second time we faced the long line of fences leading down to Bechers, only now we were pursuing just one horse nearly a fence in front, whilst the rest of the runners toiled in our wake. For four fences Spanish Steps and Red Rum jumped together upsides, until, imperceptibly at first, Red Rum began to draw away from us. By the time we jumped the Canal Turn for the second time, he was well clear of us, but Crisp still seemed an impossible quarry to catch. Brian Fletcher was working hard on Red Rum and the horse appeared to be finding more resources the further he went, unlike my mount, who was very tired. I knew that, unless the two in front fell, we were beaten. Three fences from home, Hurricane Rock and Bob Champion joined us for a couple of fences before dropping back. As we jumped the last, the thrilling drama taking place out in front of me on the run-in was making racing history. The devastating gallop set by the heroic Crisp was telling and, approaching the elbow, he was desperately tired and was starting to wander off-course. His jockey, Richard Pitman, summoned his last reserves of strength to lift his horse over the line, but it was to no avail. Mercilessly, Red Rum and Brian Fletcher bore down on them in the last few agonising yards and swept to victory. Many lengths behind them, Spanish Steps, exhausted, struggled up the run-in only to be overtaken and beaten into fourth place by L'Escargot, who had made late headway. On pulling up, my first reaction was one of disappointment, but I knew that this must have been an historic Grand National. I was not surprised when I learned that the race had broken the course record by nearly twenty seconds – an incredible half-minute faster than the average time. In future years, Red Rum's reputation as the greatest Grand National horse ever was confirmed, and Crisp's remarkable performance under twelve stone must surely be rated as one of the greatest feats by a horse round Aintree. He was never to run in the National again, but at the age of eight Red Rum's glorious career had only just begun and our paths were to cross again.

Chapter Two

THE COMMISSION

"HOW WOULD YOU like to do a life-sized statue of Red Rum? You've always said you would like to do something big." John Hughes, the Aintree Clerk of the Course, made this suggestion quite casually when we bumped into each other at the Liverpool Grand National meeting of 1985. Sculpture had taken over my life since retiring from the saddle in 1982. I had been combining the two careers for several years before finally feeling confident enough to make sculpture a full-time commitment. Although success had come quickly with a one-man show in London that had exceeded my wildest dreams, I was anxious to progress artistically. This, I hoped, would take the form of working on a larger scale, despite all the attendant problems, and also of tackling subject matter other than racing. Unfortunately, because of the enormous costs of casting, it was impossible for me to diversify unless a commission was forthcoming. However, I was convinced that my unfussy style would be suited to large-scale work.

A life-sized statue of Red Rum was a wonderful prospect, my mind raced with excitement and ideas tumbled over each other. How should I position it? What materials should I work in? How best could I capture the horse's spirit? All this was academic at that moment, as the commission had barely been mentioned and was still a long way from becoming a reality.

The idea for the statue had emanated from Major Ivan Straker, Chairman of Seagram Distillers, as well as from John Hughes. Seagram, the wine and spirit company, had started sponsoring the Grand National in 1984 and Aintree already owed a huge debt to Ivan, not least because it was he who was largely responsible for saving the racecourse some years before, when it looked as though it would finally be sold off for development. The dramatic restoration of the racecourse included an ambitious plan to rebuild and rejuvenate the antiquated buildings and stands, Ivan felt that it should also incorporate a permanent tribute to the greatest horse in the history of the Grand National, Red Rum.

Some months after our meeting, John Hughes and I were still corresponding about various details of the job. For something that was so important to me, development was painfully slow. I was eager to progress with the work and was just beginning to think that nothing was going to come of it when Ivan invited me to lunch at the Cavalry Club in London in August. We

were joined at lunch by Georgiana Bronfman, who was the wife of Edgar Bronfman, Chairman of The Seagram Company. I had met Georgiana the year before at a dinner party and I knew she liked my work, as she had bought a couple of pieces. Although the statue was very much Ivan's brainchild, it had to meet with the approval of members of the parent company in North America. We discussed the nature of the statue and some sketches I had done to give them an idea of my interpretation. I had thought very carefully about how I would like to depict the horse and I was most anxious to portray him in movement. This, I felt, was essential to capture successfully the essence of his character and to give the piece impact. My rough sketches conveyed various ideas along these lines and Georgiana and Ivan enthusiastically agreed with the concept. Ivan explained that in 1988 they would be celebrating the 150th running of the Grand National at Aintree. The year would also coincide with Seagram's fifth consecutive year of sponsorship of the race, so it seemed an obvious time to unveil the statue.

Since I was itching to get started on the project, 1988 seemed to be light years away. I made up my mind to embark on the work immediately, even if it did mean finishing early. I gave myself one year to concentrate on the project. This would allow me ample time in which to complete the job but also keep it fresh: I was afraid that if I allocated myself a full two and a half years in which to do the piece, fitting in other projects along the way, it would become over-worked and stale.

"Well, that's the statue settled, but before then I want you to make us a new trophy for next year's Grand National. Is that possible?", asked Ivan, bringing me back to earth. The answer was, of course, "Yes" and I agreed to send him my ideas as soon as I had them down on paper. I walked out of the Cavalry Club feeling highly elated. I had been commissioned to produce the two most exciting sculptures of my career. The statue would be the first life-sized equestrian portrait to be erected on a British racecourse and I was to create it. A new Grand National trophy was a highly prestigious commission, but it was also an opportunity for me to combine my actual racing experience with styles for portraying jumping horses that I had experimented with over the last few years. Since this commission had to be delivered to Seagram by the end of January, I put all thoughts of the statue out of my head and concentrated on the trophy.

My task was to create a bronze that powerfully summed up the drama and unique quality of the race. This was a sculpture I could get my teeth into. Undoubtedly it was an advantage knowing Aintree like the back of my hand – I had ridden round there on many occasions. I had also been

exploring new and exciting ways of freeing the horse from the restriction imposed by the bronze medium. A subtle series of balancing connections between figures gave me the opportunity to model my horses with only one leg and sometimes no legs at all touching the ground. This approach grew from my ambition to project the stark aggression and urgency of racing. At the meeting we had decided to incorporate into the piece three horses and riders at a particular point on the course and it had to be somewhere well known, perhaps at the Chair, Bechers or the Canal Turn. However, my main concern at this stage was how to convey the enormity of the fences without overpowering the subjects of the piece with a huge and ugly bronze structure. It had been a constant problem for me when sculpting horses jumping and I had come to the conclusion that, however well modelled, a typical steeplechase fence in bronze distracts the eye and disrupts the composition. It usually has to be shown as a stark cross-section which totally dominates the work – a grotesque block of bronze. Additionally, the presence of the fence effectively eliminates the important three-dimensional quality a successful sculpture must elicit.

I decided that perhaps the best way to imply the enormity of the Grand National fences was to leave them out altogether and to let the angling of subjects make the point. Hopefully the angle of the horses landing and the attitude of the jockeys would convey the dramatic effect I wanted. When dealing with a composition of more than one horse, each figure can lend support to the other if joined at various points. The difficulty is to avoid the connection looking obvious. A couple of years before, I had modelled two horses landing over a fence. Each horse had only one leg touching the ground, which would have been impossibly unstable if the two parts had not been joined by one of the jockey's feet touching the quarters of the other horse. I had taken this a stage further on another occasion with three flat racehorses in a finish. The middle horse was not touching the ground at any point, but was supported unobtrusively by the other two.

As a sculptor I prefer to eliminate as much clutter as possible from my work and this might include not only the fence but also superfluous details, such as particular sorts of tack. During the excitement of a race, and when observing movement in general, the naked eye cannot absorb every detail of what passes before it and consequently slavish depiction of the finer details of saddlery, such as buckles, etc., only serves to arrest the movement. With a commission it is important to be accurate about, for instance, the type of bridle a horse may race in, but I try to make it as unobtrusive as possible. Pieces that do not portray particular horses allow much more

freedom to pare down unnecessary detail to the minimum, allowing the form of the sculpture to come through. I feel strongly that this quality is an essential part of capturing form and movement.

After playing around with several ideas, I submitted some sketches of four possible subjects for the trophy to Ivan. The first two were fairly conventional, one with three horses jumping the Chair and the other of a similar group jumping Bechers. In both designs I included the fence, as I thought that I should give Ivan the chance to choose the traditional approach if he felt strongly about it. However, I did point out my artistic reservations, along with the purely practical concern that the additional weight of the fence would make the trophy terribly heavy. Number three design was the one I was plugging. The concept involved three horses landing in various stages over Becher's Brook. The one in front would already have landed and, whilst recovering from the drop, would be getting away from the fence. The two horses following would be coming down very steeply, one of them landing well, but the other touching down precariously. I was sure the result would make an exciting and original sculpture that fulfilled every requirement. Technically it was going to be fairly difficult to execute and, since the figures would not have a fence to support them, it was essential that the design was strong and would stand up to the inevitable wear and tear of a perpetual trophy. It is assumed that bronzes spend a fairly uneventful time sitting on their owners' sideboards. This is not always the case – one of mine was once used as a missile during a marital disagreement; another was scoured with a Brillo-pad by the cleaning lady, who wanted to get rid of the "horrid brown colour"; and yet another, a trophy, having been placed in the centre of a dining-room table during a post-race celebratory dinner party, was sent crashing to the floor when the table collapsed. So, the Grand National trophy would have to be robust, if nothing else.

Since one of the two horses at the rear of the group would be landing on one leg and the other on just two legs, I had to design them in such a way that they could be joined together unobtrusively to give additional support. Even so, this alone would barely give the trophy enough strength to stand up to the treatment that was liable to be meted out by ecstatic and possibly even inebriated winning owners for the next ten years. For extra support I designed the tail of the front horse so that it was just touching the shoulder of the middle one. Thus, all three models would be locked into each other to create a robust trophy that would combine strength with subtlety in a flowing design.

My fourth submission to Ivan was a rather curious logo-orientated design

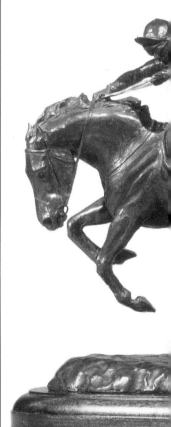

The Seagram Grand National Trophy

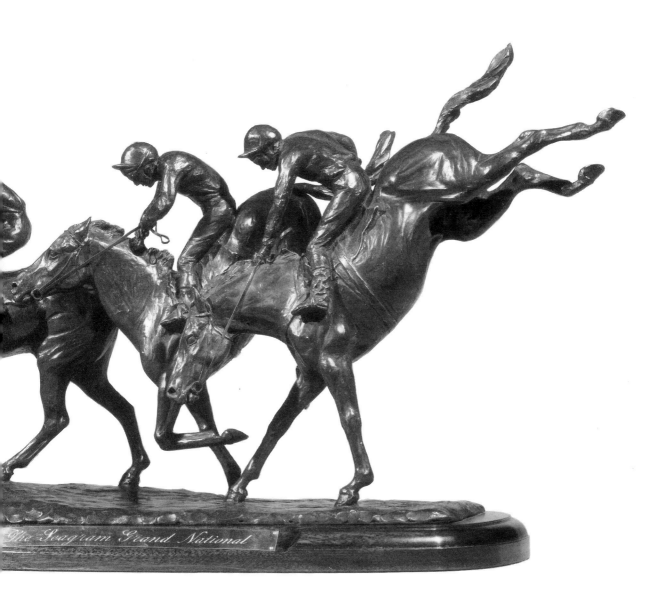

The Seagram Grand National

which incorporated three horses and jockeys forming an arc as they leapt an imaginary drop fence. They would be joined to each other and supported at the top and bottom by the circular top of a winning post, which would encompass the entire piece. I had the idea for this bronze after I created a trophy for the grandly titled World National Hunt Jockeys' Championship. For that I designed a horse jumping through the armillaries of a globe made of copper, with the equator acting as supports. It had worked well once, but was perhaps not such a good idea when adapted to the winning-post concept. Anyway, it was dismissed by Ivan, in his usual frank way, as the most disgusting thing he had ever set eyes on. He chose the project I had hoped he would and I set about my task with relish.

A complicated design, such as this Grand National trophy, has to be carefully worked out beforehand. If improperly balanced at the start, the piece not only becomes unsuccessful aesthetically, but also unstable. Throughout the creation of the piece the figures would sometimes be looked at and worked on collectively, but each one would also have to be attached to a section of the base that could be removed from the others. This would be essential not only to allow me maximum access to each figure, but also so that the founder, on receiving the piece for bronze casting, could make separate moulds from each one. The joining-up process would take place after they had been cast. So, the board on which the model was to be attached would have to be cut into three sections that could be slotted together when the piece needed to be viewed as a whole. Attached to each section would be the armature. Any sculpture built up in a malleable material requires an armature, or support, which is strong and secure. It is a simplified metal skeleton which will carry the weight of the modelling material and is as important as the internal structure of a building. It has to be thought out carefully in advance, because an ill-made or weak armature is not only frustrating but can also doom the work to failure. This is always an exciting stage for me and, when working on a small scale, creating the armature is achieved comparatively quickly. For the first time an idea becomes actuality and begins to take shape three-dimensionally. When the armature is finished, the bones of the work are in place and the sculpture should, if it is going to be successful, already capture the movement and mood of the finished piece. With small work, such as this, I use an oil-based clay, similar to plasticine. The material is, admittedly, not as pleasant to work with as clay, but it does have one great advantage that outweighs this minus factor – it does not need to be kept constantly damp.

Modelling the trophy went fluently and it was completed within a few

weeks. To achieve the best effect, I have to work quickly so that enthusiasm is retained and a freshness is preserved. A work which is beset by problems is discouraging and the model very soon takes on a laboured appearance which can never be erased. The temptation is always to persevere when weeks and sometimes months of work have gone into a piece, but for me, after I have grasped the nettle and scrapped a work that is not coming right, I feel as though a burden has been lifted from my shoulders. On completion, I took the trophy to the fine art foundry of John Galizia and Son in Battersea. Run by Vincent Galizia, son of the company's founder, this small foundry achieves a measure of excellence rarely seen today. Since it is a highly skilled business, standards of casting can vary enormously from foundry to foundry. Due to the meticulous care and traditional techniques used by Vincent, his costs and consequently his charges are high, but there is nothing more infuriating than seeing one's work become a travesty of the original because of poor workmanship. Over the years I have built up with Vincent and his small team a good working relationship, which is important if a sculptor's requirements are to be interpreted correctly. As usual, he made a superb job of the trophy. In addition, he cast the rear horse on its own (I had designed it with this in mind), so if could be presented to the winning owner as a permanent trophy. This we did in preference to making a miniature of the original, as we felt it would be better to have a trophy that was on the same scale as the main one.

With the trophy completed, I turned my thoughts to the statue. In all my work I try to evoke a mood or a moment. So, what was the mood to be expressed in the statue? I had already decided that motion would be incorporated into the work in one way or another. I obtained from the B.B.C. some video tapes of Red Rum racing and of him being led in front of the stands at Aintree after he had retired. Then I went up to see him in Southport. The purpose of this visit was not to make an intense study of Red Rum physically, but merely to get a better idea of the sort of horse he is. Much has been written about Ginger and Beryl McCaine's yard at Southport, but I was still surprised on arrival to see the racing stable tucked away behind Ginger's garage in the suburbs. Somehow it all seemed so incongruous. Ginger and Beryl could not have been more helpful and showed me great hospitality.

The horses were just pulling out for second lot and Red Rum was one of them. At this time he was still being exercised daily with the rest of the horses. I was legged up onto another animal, so I could observe my subject whilst out exercising. The string threaded its way through the streets of Southport until we emerged onto the beach where Ginger had trained Red

Rum to win three Grand Nationals. As soon as the horse felt the sand under his feet, he came alive. Crossing the sands, he jig-jogged, first one way, then with a buck and a squeal he would go the other, snorting and arching his neck. A strong sea breeze whipped up his mane and tail as he pawed the air, creating the romantic image of freedom that the wild horse has symbolised for centuries. The germ of an idea was forming in my head. On the way back, Red Rum continued with his antics, throwing himself about the road like a two-year-old, managing to avoid the traffic which appeared to keep a respectful distance to allow the maestro to indulge in his eccentricities.

Having been a professional jockey, I tend to take a non-anthropomorphic and realistic view of horses' capabilities: most of them do not seem to be endowed with vast amounts of brain power. Red Rum is an exception. Just two weeks before I witnessed his high jinks at Southport, I had attended a pre-Grand National dinner given by Seagram at The Prince of Wales Hotel. After the meal, Red Rum arrived as the surprise guest. He stood in the ballroom like a rock whilst guests clamoured round him. He was within a couple of feet of dining tables and never moved a muscle, but stood alert and interested for a full half-hour under the spotlight before being led away. In fact, the horse was the only saving grace of what turned out to be a disastrous evening. The gathering consisted of Edgar and Georgiana, who had flown in from America that day, Ivan Straker and many Seagram clients and representatives from all over Europe. After Red Rum's departure, things took a turn for the worse. The cabaret organised by the hotel was so embarrassingly bad that Ivan left his seat and stood in the wings imploring the comedian, in a whisper, to come off. This he resolutely refused to do until the head waiter jumped up and physically dragged him from the stage, protesting loudly, whereupon the entire band downed instruments in sympathy. To put the lid on the evening, it was discovered that a number of the suites on the top floor had systematically been robbed while the guests were downstairs and Georgiana had had most of her jewellery stolen.

On my return from Southport, the picture that remained in my mind was of Red Rum revelling on the beach. This had to be the theme of the statue. The horse would be up on his toes, as he so often is, jig-jogging, slightly sideways. His mane and tail would be blowing free, as if he were out on the sands, and his head and neck would be held in that unmistakable pose, high and outstretched. I felt that this would capture the horse's vitality and vibrant nature and would incorporate just the right amount of movement. There was no need to portray him galloping, any more activity would be a creative overstatement and would prove aesthetically unacceptable.

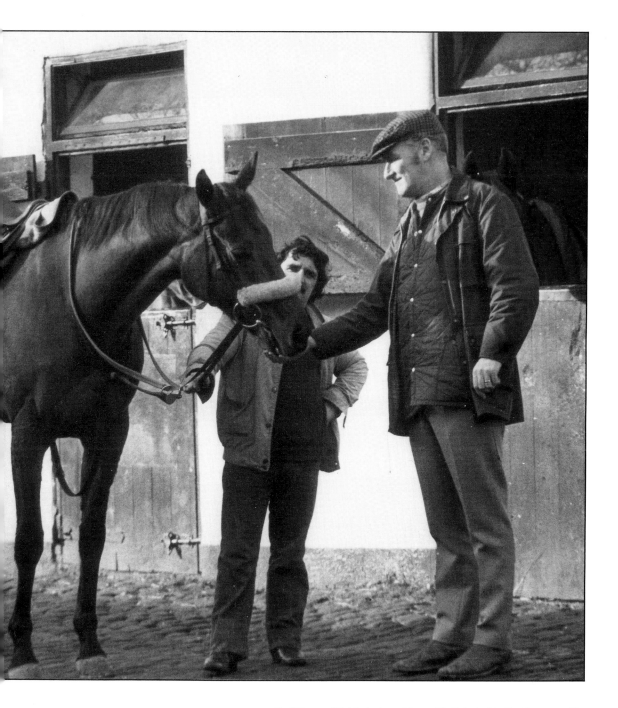

Red Rum with his trainer Ginger McCain in his Southport stable.

Red Rum does a fast work out on the regularly
harrowed strip on the Southport sands in the
days before the compulsory wearing of crash helmets.

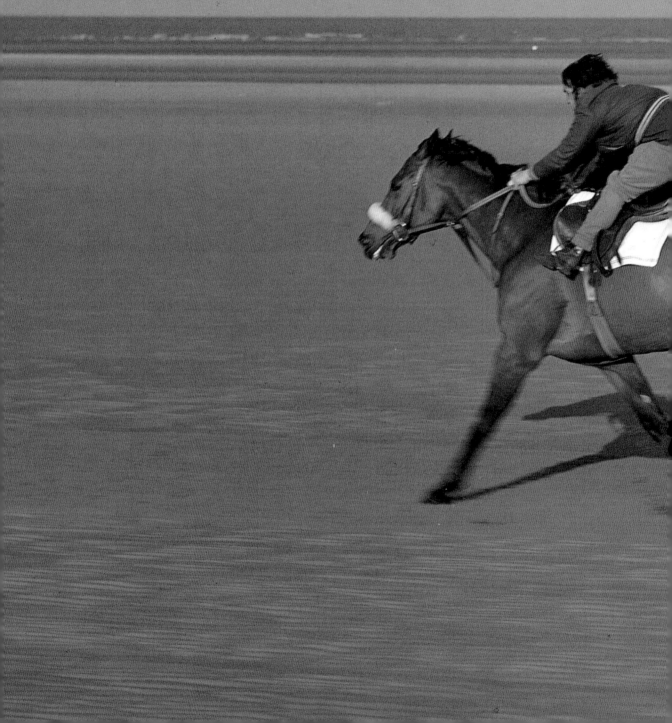

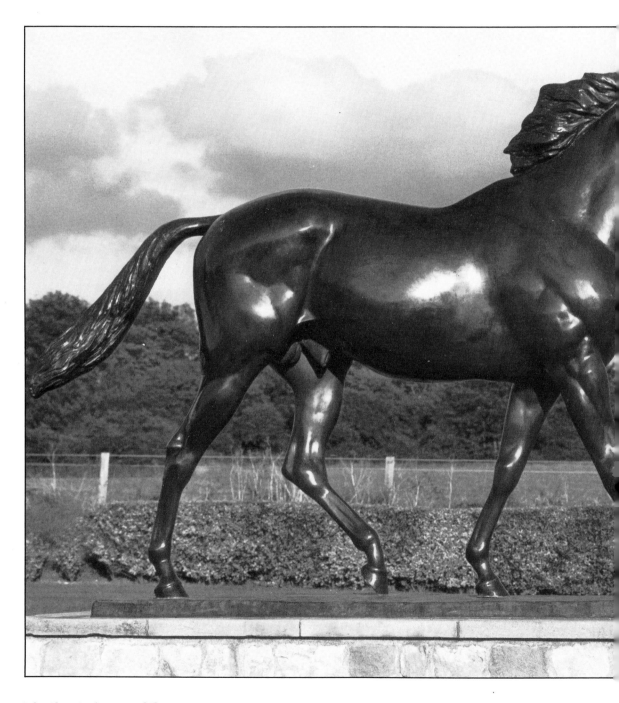

John Skeaping's statue of Chamossaire.

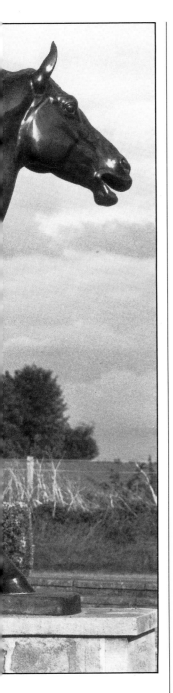

No one had suggested that the horse should be depicted with a jockey, much to my relief. Red Rum was the sole subject and so I could avoid putting a distracting human figure in a saddle: putting a man on top of a horse elevates and increases the status of the man, but inevitably shows the horse as subservient. I suppose there will be those who would have liked to see Red Rum exactly as he was when winning the National, with a jockey, tack, plaited mane and sheepskin noseband. All these additions may have helped people to recognise the horse on a superficial level but, in my opinion, they would have obscured the true likeness of the horse and reduced the concept from a romantic to a pedestrian level. These considerations apart, it would have been impossible to decide whether to have Brian Fletcher or Tommy Stack as the jockey.

Some time later, I visited Gerry Cranham, a photographer who kindly let me have some wonderful photographs of the horse on Southport sands which were taken when he was at his peak. These further inspired and helped me to immortalise the horse in my chosen way. I should also mention here the late John Skeaping, who has always had a strong influence on my work. I went to Newmarket to see again his two life-sized statues of Hyperion and Chamossaire, both situated at studs in the area. Skeaping had a wonderful ability to cut away unnecessary detail and get to the heart of the sculpture. I am not, I must admit, a fan of all his work, but at his best he was unsurpassable. His bronze of Chamossaire is, in my opinion, a masterpiece. I have no idea how closely it resembles the horse and its romantic outlook is, I dare say, not to the liking of everyone in the racing world, but its beautiful simplicity and tactile quality give it a powerful impact. John Skeaping was, I am told, an excellent teacher and he guided his pupils with enthusiasm, without ever imposing his own style upon them. Towards the late 1970s he offered me the chance to go and stay at his house in the Camargue, as a pupil, during the summer off-season. To my great regret and disappointment, he cancelled the plan through ill-health and pressure of work brought about by his forthcoming major retrospective exhibition. His style and simple approach have undoubtedly affected the way I have handled the Red Rum statue, but I think it is inevitable for all artists to be influenced, to a greater or lesser extent, by their predecessors.

Another man who influenced me significantly was the Italian sculptor, Rembrandt Bugatti, who lived in the late nineteenth and early part of the twentieth century. Bugatti's pieces always appear to have a spontaneity about them, evolving from the speed at which he worked. My work has, I feel, more reference to him than to any of the earlier nineteenth-century

animalier sculptors who tended to be preoccupied with intricate and detailed representation. The outstanding exception was Barye, whose work contained a strongly romantic vein, and was less inhibited than that of his contemporaries. He managed to achieve dynamism and vitality through form, which I hoped to try to emulate with the statue.

As a jockey, I observed these works, and many more, with a growing fascination before I ever felt the desire to pick up a piece of clay myself. Although I drew and painted fairly seriously at school, the artistic side of my life lay dormant whilst I applied my creative talents to coaxing reluctant horses to go faster than they wanted to. I did, however, feel a growing affinity with three-dimensional art, and with it came a vague desire to try my hand at sculpture. I also felt I was in a unique position and had something to offer. If I could master the technique of modelling in clay, for the first time racing as seen through the eyes of a professional jockey would be reproduced sympathetically with all its drama and excitement. However, I rather doubt whether these sentiments would ever have crystallised, galvanising me one day into action, if it had not been for a chance meeting that was to change my life.

Chapter Three

A NEW COURSE

I SET OUT for Devon and Exeter Races one wet December day in 1973 with my mind tuned to the pressing and practical dilemmas of a struggling jockey. In the car with me was Ron Vibert, the trainer of one of the horses I was to ride that day. Because of the petrol crisis at the time, we were all trying to save fuel, so on the way we picked up Ron's owner, a lady by the name of Margot Dent. I discovered she was a sculptor and we fell into conversation. Normally, the talk during the journey to the races with the trainer consists of a discussion about tactics and an assessment of the opposition, with a little racing gossip thrown in. On this occasion, racing was pushed aside and we discussed sculpture. I discovered that Margot had been a pupil, many years before, of John Skeaping at the Royal Academy School of Art. Our discussion about the basic mechanics of sculpture stimulated me and I resolved to have a crack at it as soon as I could. Margot encouraged me to have a go.

"You won't know if you're any good if you don't have a try", she said. The importance of our meeting was not, of course, apparent at the time and the day's activities soon pushed from my mind any thoughts other than the immediate job in hand. I had a good day and rode two winners, but unfortunately Margot's was not one of them. Her horse finished un-placed, after damaging a tendon, and it never ran again.

The very next day, fate turned against me with a vengeance. I was riding Spanish Steps in the SGB Handicap at Ascot. Since there was no front runner, the early pace was very slow. On approaching the second fence Spanish Steps misjudged his take-off point and stood off much too far for the speed we were going and he fell heavily. The horse was uninjured but I hurt my wrist, yet again. I went home feeling thoroughly depressed. The following day, Edward Courage gave me the sack. I was not surprised and could not, in all honesty, blame him. Despite riding several winners for him our joint fortunes had deteriorated and a change was needed. I had, perhaps, been a little unlucky, having infuriatingly been second on both the stars in many big races, including the two-mile champion chase at Cheltenham in which I suffered a close beating on Royal Relief. The rest of the season did not go well for me. I was back to riding as what I euphemistically called a "freelance", which meant scratching around for

any spare rides going, Luckily, the late John Thorne, a west-country trainer with a small string, employed me regularly and I rode the odd winner for him and for one or two other small trainers. Clearly I was out of fashion and when you are no longer in vogue in the racing business, you soon find out in no uncertain terms. By the end of the 1973-4 season I had decided that racing was trying to tell me something and that I should take the hint and get out.

Injury had also provided a consistent interruption to my career and I was becoming disillusioned with it. In fact, the worst incident had occurred on my third ride as a professional when I had broken my thigh. One second I was hurtling towards my first winner in the paid ranks and the next I was lying writhing under my horse at the second last with a fracture that was to put me in hospital for three months. I had returned to the saddle six months later with a permanently bowed leg, but with my enthusiasm still intact. Since then, I had broken my wrist no fewer than four times with countless other cracks and sprains which had meant lost opportunities for a jockey trying to make an impression. All jump jockeys accept a certain amount of damage as inevitable, but my misfortune always seemed to come at the wrong time. The problem was that I could never afford to allow the wrists to heal properly, for to do so would have meant missing more rides and, therefore, more winners. Consequently the fractures and strains had an accumulating effect on the strength of my wrists. In later years I wore leather wrist straps which protected them from injury. I was as keen as ever, but my ambition was always being thwarted. To cap it all, I was stony-broke. The last two catastrophic seasons had landed me in a financial situation which, in the words of my bank manager, could "not be allowed to continue".

What could I do? I had been a professional jockey for the past five years and knew no other occupation. Lacking a better idea, I decided that I might try show jumping because I had had some success at it as a teenager. My mother found me a remarkable pony when we were living in Northern Ireland. Over there he was classed as 14.2 hands high and therefore eligible for junior classes. We were highly successful in Ulster, unfortunately the English authorities took a less liberal view on the height limit and we were forced to compete against adults. In spite of this we still managed to win a good proportion of open classes.

I applied for a job with a top show jumping stable which, thankfully, turned me down on the grounds that it hadn't yet come across a jockey who could ride properly. However, a small stable in Surrey offered to put me on the bottom rung of the show jumping ladder and I spent the summer rather

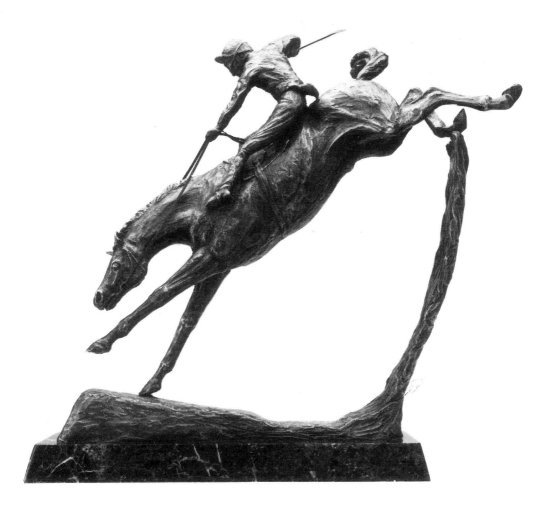

One of my early pieces, entitled 'Bechers'.

half-heartedly learning the trade. I was officially an ex-jockey now, so the opening day of the new National Hunt season found me sitting in a tack-room in Surrey, staring wistfully at the newspaper and the card for Newton Abbott. "What the hell am I doing here?", I thought. "I don't even like show jumping." At that moment I decided to re-apply for my licence and to try again. Unfortunately I had told the few trainers involved that I was packing in and a lot of them had made alternative arrangements. It was going to be a struggle. That season was the nadir of my riding career, but it was such a relief to be back in racing after my early retirement that I felt more optimistic than I had the season before.

By Christmas I had ridden the grand total of three winners. Then, as so often happens, January brought a long freeze-up and, with it, enforced inactivity. For some unknown reason my conversation with Margot over a year before came flooding back to me and I realised this was a chance to

try my hand at sculpture. The following day I made a trip to the library in Oxford and selected several books on sculpture technique and anatomy. Afterwards I went to an art shop and bought myself some tools, some wire and some clay. I returned home, opened the book and read, "Before setting out, the reader needs to have an intimate knowledge of anatomy and a thorough understanding of the meaning of art." That ruled me out, for a start. I read two pages before despondently putting the book down. Then I picked up the clay and wire. My eye scanned the room for a subject. I grabbed my black labrador, manœuvred him into the pose I wanted and started work. Six hours later I sat back to assess my labour. Never in my life had I been so absorbed. Those six hours had passed like six minutes, but they had been filled with excitement and frustration as I tried to will the clay to respond. From then on my fairly frequent non-racing days were consumed with modelling in the makeshift studio in my cottage. I would return from riding out at Lambourn at about 11 a.m. and happily settle down to long hours of creativity.

That season saw a slight revival in my racing career but as soon as summer was over, I lost no time in contacting Margot Dent. I had not seen her since our trip to the races a year and a half before, so I felt a little uncomfortable about telephoning. I was soon put at my ease and she invited me down to give me an assessment of my work. With trepidation I produced the model of my dog and one or two other pieces. Looking back now, I realise that the work was poor and amateurish, but Margot knew discouraging talk could only be destructive at that moment. With tact and enthusiasm she picked out the good points, giving me the fillip needed to send me on my way day-dreaming of becoming the next Rodin. What was more, she and her husband, John, invited me to stay with them on their farm for as long as I liked, to work and to learn.

There is no doubt that fourteen years as a professional jockey made an enormous difference to my approach to the medium. I started sculpting during my riding career, so it was natural that horses and racing would be the source of my inspiration. At that time I was preoccupied with trying to convey, through bronze, the feel and authenticity of racing. Fortunately I soon found that I had a natural flair for capturing movement, although the finer features were, at this point, lacking. The more I worked at it, the more conscious I became of the need for technical skill and anatomical knowledge. With this skill and knowledge came the freedom to experiment. Ideas I was not short of – it was the means to carry them out I needed, and that was where Margot came in.

That summer of 1975 was the first of many happy times spent at

Broughton, where I would lose myself in sculpture. Every day I would model under the patient guidance of Margot. My first horse was not, at the outset, a resounding success. I had decided to portray a horse, after a Stubbs painting, laying his ears back and kicking out. Having been with horses all my life, I was pretty confident I knew what they looked like. For days, unknown to me, Margot had debated with her husband about the wisdom of telling me – a jockey who was supposed to be an expert on horses – that I really had no idea what they looked like. John eventually said she must tell me. So Margot took me down to the field and pointed out some obvious points that had eluded me on a live example grazing in front of us. I realised that observation was the key to figurative sculpture.

Getting work cast is an expensive business and I still had a long way to go before I attained a high enough standard to warrant taking the work to a foundry. However, there was an alternative. Margot had some experience in casting with what is deceptively called "cold cast bronze". I say "deceptively" because cold cast bronze is, in fact, polyester resin with some bronze powder added to create a bronze effect. The techniques of casting in this fashion are so sophisticated nowadays that many people are fooled by dishonest dealers into thinking that what they are buying is the genuine article. Even if they are advised that it is "cold cast bronze", they quite naturally assume that this is an alternative form of casting to the lost wax process. Of course what they are buying is not bronze, or for that matter, metal of any sort, but the process is ideal for sculptors who can't afford foundry charges. The results can be quite stunning and almost indistinguishable from the real thing. It is only dishonest when a piece is passed off as something it is not, which unfortunately happens all too often. Frequently people bring so-called bronzes to me that have been dropped and broken, wondering how to repair them. I have to tell them that their sculpture needs resin and hardener rather than being brazed at a foundry. Anyway the process was ideal for me and the treatment of my Stubbs horse.

The whole of July was taken up with heating a disgusting substance called "Vynamould" on Margot's kitchen cooker, and then running out to the workshop with it once it had reached the exact temperature required. For weeks the house was filled with a pungent and toxic odour which seemed to permeate everything. Once the mould was set, we painted the resin and bronze powder onto the rubber negative and waited impatiently for it to set. An hour or two later we peeled this layer away from the mould. Whatever small amount of merit the original model had justified, my first attempt at casting made a comprehensive job of obliterating it. But it was a start and I was very proud of my efforts. I spent many hours

joining up the two halves so they fitted together perfectly and I proudly presented it to my brother and his wife as a wedding present. It was not much good, but certainly many hours of tender loving care and devotion went into its production.

With a pleasurable feeling of anticipation I returned to my cottage for the forthcoming season. The prospect looked bright. At last I felt that I was beginning to emerge from my two years in the doldrums. Unfortunately I soon realised once the season was under way that trying to combine sculpture with racing was impossible. My creative output would have to wait until the summer.

The trainer Alan Jarvis, who had a medium-sized string at Coventry, had offered me a retainer. On top of that I was riding for John Edwards, a trainer whose strike rate from comparatively few runners was formidable, of course now he is one of the country's leading trainers. I was also riding for a new trainer called Michael Oliver. Michael only had a small number of horses, but at the tail end of the previous season I had ridden a winner on a young novice of his recently over from Ireland who, I was convinced, had a great future. His pedigree was one I knew well, having won on both his half-brother and his sister. The horse's name was Master H and he had emerged to win his first novice hurdle by ten lengths in a way that impressed me.

Alan Jarvis turned out to be a good man to ride for. His was a betting stable and both he and most of his owners loved to have a gamble. Here was a different aspect to riding winners. The most heinous crime to commit with the true gambling owner is to ride a winner when he is not "on", so to speak. I soon realised that he would be far happier to have a huge bet and see it go down the pan than to have a winner without having had a bet. That would be a hanging offence. The net result was that with virtually everything I rode for Alan, the chips were down. Any increase in pressure as a result was more than compensated for by the financial rewards when a gamble came off. Alan was a good trainer and we had a lot of winners that season, but the star for me was Master H, who picked up six good class races. I finished up with forty winners and was well pleased.

The following summer of 1976 I went back to the Dents' to continue my artistic education. I was full of Master H and, of course, wanted to do a model of him. Margot and I travelled up to Droitwich to Michael Oliver's stables so that I could work from life. I portrayed the horse in action – jumping – and when I had made the model, I felt ready to invest the hard cash necessary to have my first piece cast into real bronze. Nothing can

describe the feeling of seeing for the first time a piece I had laboured over immortalised in metal. Proudly, I took it home and gazed at it all evening.

For the next couple of years my output was restricted by a busy riding schedule. Sculpting for only part of the summer meant getting very little new work done. At this stage I was also working extremely slowly and making mistakes which involved re-modelling. I did manage eventually to turn out a series of Grand National bronzes. I wanted, above all, to seize the atmosphere of Aintree. When time allowed, over the next year, I did a model of Becher's Brook and a more unusual piece of the Canal Turn. In the latter I omitted the fence and the horse was depicted taking a stride after landing; the jockey was pulling the horse round at an acute angle. I took a gamble on completion and asked Vincent Galizia to cast them for me. The next stage was to find a gallery that would be prepared to exhibit them. The Sladmore Gallery in Bruton Place specialises in animalier and sporting bronzes and so it seemed the obvious place to start. Confidently I took along my two Grand National bronzes to the gallery. I was sure the directors would fall over themselves in their rush to snap me up before a rival gallery got the chance. My delusion was short-lived. The young lady in charge at the time looked at the pieces rather disdainfully before pronouncing that she quite liked the jumping bronze – but then jumping bronzes didn't sell, of course – and she didn't really care for the non-jumping one. She consequently felt that it was not really worth her while trying to sell them. I walked away feeling desperately crushed. How could all that energy and excitement have produced such lack of interest in another individual? Perhaps she was right, perhaps they really were no good. I took them back to my cottage with my tail well and truly between my legs.

When next I saw Margot I recounted my experience at the Sladmore and she suggested that I visit the Tryon Gallery. I was feeling thoroughly dispirited by the recent rebuffal and replied rather feebly that I didn't think I would bother. Crisply she declared that if I wouldn't, then she would. She was as good as her word and the following week she produced the work in front of Aylmer Tryon, the director of the gallery. Apparently he looked at them closely for a while, and then said, "I think they are very exciting bronzes – I'll put them in our next mixed exhibition."

These early pieces certainly had their faults and I still had a lot to learn about composition and technique. On the other hand, I had some original ideas and perhaps something extra to offer which Aylmer was prepared to foster and for that I will always be grateful. Somewhat optimistically I put a limit of six casts on each model. In November 1978 four of my bronzes

were shown in a mixed exhibition, which also included the work of Susan Crawford, amongst many other artists and sculptors. Sue is the country's most sought-after equine painter and is immensely talented. We met for the first time at the exhibition and right from the start she was tremendously encouraging and enthusiastic. This was a real boost for me, as I had a great respect for her skill and opinion. We have been firm friends ever since then and at one time talked about holding a joint exhibition. Unfortunately her duties as the wife of a highly successful army officer and the continuous stream of commissions she receives have so far prevented this from becoming a reality. During the exhibition my work was subjected to serious criticism in print for the first time. Stella Walker's review in the magazine *Horse and Hound* commented, "The jockey Philip Blacker manages to achieve some startling juxtapositions between horse and rider in his three Grand National bronzes." Although not wholehearted in her praise, she clearly found something exciting in my work.

With growing amazement I discovered that people were prepared to pay good money for my work. As the exhibition continued, the gallery would ring me every now and then to tell me they had sold another piece. A feeling of euphoria enveloped me and I began to think I might really be able to make my living from sculpture. At that stage I found it a real compliment that people were prepared to back me and I still experience a warm glow of contentment when I sell some work, not because of the obvious financial benefit, but because the best compliment anyone can pay an artist is to invest their hard-earned money in something for its pure visual satisfaction. I believe that any artist who says that he cares only for his reputation and not whether he sells his work is fooling himself. Words are cheap, and critical acclaim has a hollow ring to it when it is not backed up by hard cash. That is not to say that one should eschew critical acclaim, for I would be the last to do so. In some areas of the art world I am branded as a horse modeller and, therefore, my work is of minor importance. Such adverse criticism of any form of equestrian art has developed for two reasons. Firstly, there is, without doubt, much inferior work in this particular area, which certainly does not help matters. Secondly, the art establishment has formed the opinion that unless a work is, in its eyes, "meaningful" it is not art. Most art is, after all, created as decoration, nothing more or less, and it is arrogant to condemn a piece as trivial and frivolous because it does not carry a message of vital importance to the world. I am content if my work enhances the lives of those who see it. I do not pretend it is of earth-shattering importance.

My three Grand National bronzes set me on my way and at last I knew

where my ambitions lay whenever I should decide to hang up my boots, but for the present being a jockey was what I did and enjoyed most. I also felt the two occupations in many ways complemented each other. Every season would bring new experiences which I could transfer to my work during the summer months. The proximity to my subject also helped to give the bronzes a sense of urgency, which I wanted to maintain. From a practical point of view, being fully involved in the racing world brought me into contact with prospective clients. On the minus side, my riding career sometimes prevented my sculpture from being taken seriously, which did not worry me much at the time; but it was a problem I had to face for a while after my retirement. I called it "the ex-jump-jockey syndrome", meaning that it was considered incongruous for an ex-jockey to turn out to be artistic and therefore my work tended to be pre-judged. When the minor success of the first exhibition became generally known, the racing press attached a certain novelty value to the story of a jockey becoming a sculptor. Consequently I received some not entirely welcome publicity about it. The problem was that at that time my main ambition lay in my riding career and there was a danger of the sculpture out-publicising the racing side of my life. Later, as my inevitable retirement from the saddle approached, I adopted a different attitude. If my riding could help promote my name as a sculptor, all well and good. I needed all the help I could get. There were times when life became slightly awkward. Very often in the paddock before a race, interested owners would start firing questions at me about sculpture or casting. One day our conversation continued until the bell to mount had gone and I was about to be legged-up onto the horse. The trainer finished tightening the girths, turned to me and said, "O.K. We've learned how to cast a bronze: now can we possibly discuss the race in hand?"

Stan Mellor was a jockey I admired because of his single-minded dedication; on hanging up his boots he applied the same devotion to training and he built up a powerful string. The odd spare ride had come my way from the Mellor camp over the years whenever an outside jockey was needed. The 1976-7 season was proving a good one for Stan, but I knew that his jockey, Jeremy Glover, was due to retire shortly, probably at the end of the season. Although I was anxious to take over the job, I thought I had only an outside chance. On Easter Monday as usual there was a glut of meetings, Stan needed a jockey to ride a novice chaser at Uttoxeter and I had been booked by John Edwards who had five runners there. So I had a ride now in all six races and each had a chance of winning. Stan opted to go to Uttoxeter rather than to one of the other meetings where he had runners

and we travelled up in the same car. On the way he offered me the job as stable jockey for the following season, providing, as seemed likely, Jerry Glover decided to call it a day. He backed up his decision with such complimentary words about my riding ability that I arrived at the racecourse with a feeling that today I could achieve anything. With a spring in my step and the words of the great Stan Mellor still ringing in my ears, I floated into the weighing-room. Changing next to me was John Suthern, to whom I announced, "Today I shall go through the card – just wait and see." That's not quite what happened, but I wasn't far wrong. The first winner was Stan Mellor's novice chaser which was not even allowed to contemplate defeat and won at twenty-to-one. I won the next on an Edward's handicapper by a short head. Unfortunately the owner of the third had taken a late decision to put on the stable's claiming jockey in order to take seven pounds off his back, so I watched the race from the stand. The horse won easily but with his inexperienced rider was disqualified for veering off-course. Of the last three races, we won two, the only failure being on a chaser which was in front at the second last, put in an extravagant leap and fell tragically, breaking a leg. That certainly marred my day, but with a four-timer under my belt the omens looked set fair for my partnership with Stan.

Chapter Four

DIVIDED TIME

WITH THE ONSET of the new season I found myself not only with a new job but also engaged to be married. I had met Sue during the summer at a party in Norfolk given by Rex Carter for whom I occasionally rode. Although she is the daughter of the trainer, Colin Davies (of Persian War fame), at that time she was not involved in the racing world, preferring to take a history of art degree before going into the antiques trade. I had to overcome a certain amount of scepticism on her part when I announced I planned to become a sculptor on retiring from the saddle. Thankfully, when she saw my work, she understood that I was serious and gave me every support. We planned to live in my small cottage near Wantage, which was in need of renovation. All we needed was the financial means to carry it out.

Luckily, help came along in the form of a horse called Explorateur. Trained by Stan Mellor, this New Zealand-bred horse was owned by a gambler by the name of Bobby Turner – a charismatic east-ender. So often the horse owned by a big punter is a moderate performer and not worth backing but, as fortune would have it, on this occasion Explorateur certainly landed the odds for the owner. Clearly Bobby was in a cash business, as that was the only currency he ever dealt in. On his second appearance on a British racecourse I rode Explorateur to win a novice hurdle at Sandown. After the race huge wads of notes protruded from every pocket of the Turner entourage. Never have I seen so much money flying around. That, I thought, would be the end of it . . . but it wasn't. The horse kept on winning and Bobby was reputedly punting between £30,000 and £50,000 every time. On each successive occasion the Dom Perignon and cash flowed in increasing amounts. After the horse had won for the fourth time, one newspaper reported that Explorateur had taken more out of the betting ring that season than any other horse. However, the whole gravy train came to a dramatic and unexpected end. We always suspected that Bobby was sailing close to the wind and we didn't ask too many awkward questions about his business, but we were staggered when he was arrested in a dramatic swoop by the drug squad. Apparently he had been the head of a marijuana smuggling ring which the police had been tailing for some time. On reflection, it was not surprising that they caught up with him – he had hardly been keeping a low profile. When he was sent down for several years, I, for one, was sorry,

because he had always seemed to me to be a nice guy and his flamboyance had certainly brightened our lives. In the early days I remember Bobby was always closely accompanied by an associate known only as Dennis. Suddenly Dennis no longer appeared at the races. Once or twice I asked Bobby what had happened to him and how he was. His mysterious reply was always the same, "Dennis has been a naughty boy." Quite what that meant, I never discovered.

Riding as second jockey for Stan was Steve Jobar, who was a friend of some years' standing. Steve was born and bred in Sheffield and had come down to live in the south on entering racing. For some reason he always attracted incident and controversy, wherever he went or whatever he did, the unpredictable happened. Seemingly unaffected, he would carry blithely on as if nothing had happened, leaving a trail of havoc in his wake. On various occasions before I was married he would take refuge in my cottage after finding himself temporarily homeless. On one occasion, I was awoken at two o'clock in the morning by someone throwing stones at the windows. Peering out, I saw Jobar standing in the pouring rain, begging to be let in. He then explained that he had had a row with the landlord of the pub where he was living and would be grateful if he could stay a couple of days until he found alternative accommodation. Six months later he was still in residence.

That summer he offered, in lieu of rent, to help me build a studio in the garden. Luckily there was the remains of an old stone shed, but even so it was still a fairly major task to convert it – in fact, it virtually had to be built from scratch. Since Steve was fairly good with his hands, I readily accepted his offer. Everything went to plan until we came to making the roof. Having reinforced the existing walls, Steve prepared a seemingly perfect design, incorporating one vertical side with glass panels, facing north, and the other sloping at an angle of forty-five degrees. As the studio was fairly small – about twelve feet square – the plan was to build the joists and frame on the ground and to lower the entire structure into place. We would then tack down felt-covered plywood to give final protection. When we came to lower the frame into place, it suddenly occurred to me that the whole idea had one flaw: there was nothing to hold it down. When I voiced my fears to Jobar he replied with confidence, "Don't worry, it's held down by its own weight." So we put the frame into position and retired for the day. The following morning we went out to admire our handiwork. Out in the middle of the next field was our roof, the wind having gently lifted it from its resting place and deposited it thirty yards away . . . Back to the drawing board!

Steve was always thinking up hare-brained schemes to make money, only to abandon them when a better idea came along. At one time he

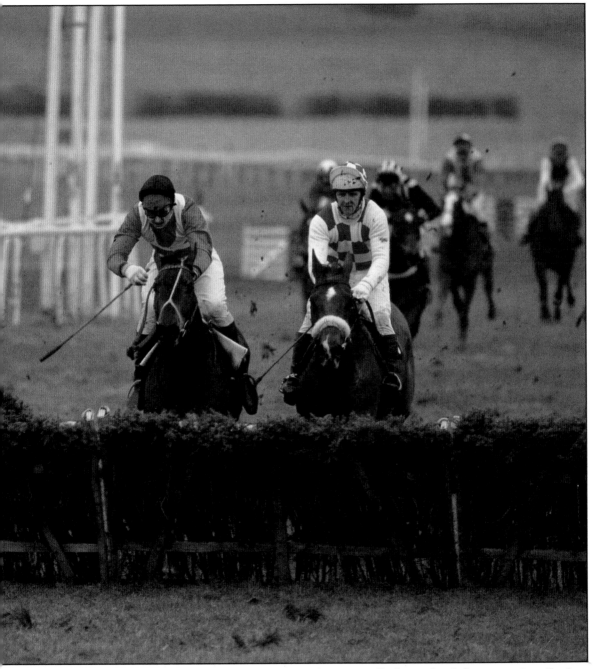

The last flight in the 1979 Daily Express Triumph Hurdle. In the centre Pollardstown heads for victory. One of his less appealing traits was to take the odd hurdle by the roots when the chips were down. He is about to do just that here.

decided he would make his fortune building sauna baths. After six months he produced a beautifully and professionally built prototype. Unfortunately he had taken little account of the accumulated costs, which meant that to make a profit the bath would have to be sold at wholly unrealistic price. He finally sold me the original at cost price and it gave many good years' service, but that was the end of Steve's sauna-making enterprise. Steve's innovative bias meant he always held rigidly to his own ideas about how to do things and totally disregarded the tried and tested methods. He had a completely cavalier attitude to any sort of safety precautions, which inevitably led to some near disasters. On one occasion he decided he would carry out electrical repairs to my sauna bath and proceeded to saw through a live cable with a kitchen knife. Unfortunately, I was actually in the sauna at the time and unaware of his dangerous intentions. A loud bang left my kitchen knife blackened with a large chunk ripped from the blade, but, miraculously, Steve and I unscathed.

There were times, however, when it was an asset to have someone else staying in the cottage. Once in the days before I started riding for Stan, I had been wasting hard all week in preparation for the Swedish Grand National the following Sunday. Weight problems had plagued me since the start of my career and for this race I was trying to get down to ten stone, which was below my accepted minimum. All week I had been restricting my liquid intake. On Wednesday I had a particularly hard day at Cheltenham, having been involved in several tight and tiring finishes. On the way home in the car I began to feel a slight pain in my kidneys. This did not worry me unduly, as my kidneys had been known to raise the occasional objection to the dehydration treatment caused by continual sauna-baths. That evening the pain continued to bother me, but I went to bed. At two o'clock I awoke with a searing pain which felt as though a knife had been plunged into my side and was being twisted and turned. Having run round the house and up and down the stairs a few times in an effort to escape the agony, I decided I needed to get to hospital. I would have to wake up Steve. Alas, the bold Jobar had been to a party that night and had returned somewhat tired and emotional. Even in my state I could not rouse him. In desperation I grabbed his ankles and dragged him out of bed. He awoke as his head hit the floor with a thump. Somehow we reached the John Radcliffe Hospital in Oxford, where I was immediately admitted, and a short time later a stone in my kidneys was diagnosed. I was kept in for several days on a diet of water, water and more water until the stone had dissolved. That was the kiss of death to my weight loss and trip to Sweden, but after that I had more respect for my kidneys

Most Grade 1 courses incorporate a sauna bath in the jockeys' room and here
I expose my magnificent torso to the camera in between bouts in the oven.

November 1981 £1.95 £2.85 in Eire including all taxes. $4.50 in the U.S.A.

pacemaker

INTERNATIONAL and STUD & STABLE

£3,000 Ten to Follow Competition

NH Trainers give their Horses to Follow

Jim Wilson talks about Little Owl

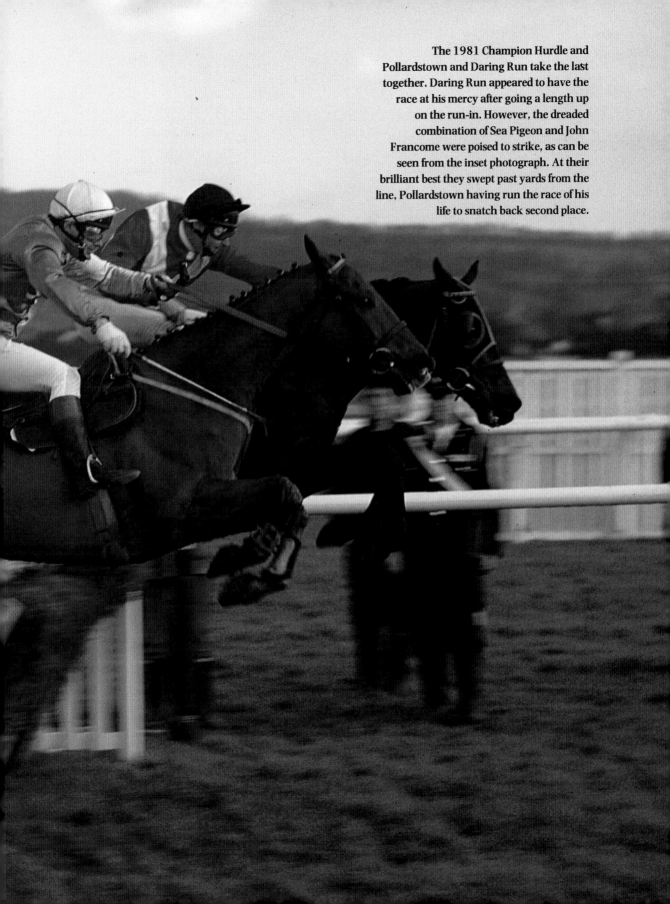

The 1981 Champion Hurdle and Pollardstown and Daring Run take the last together. Daring Run appeared to have the race at his mercy after going a length up on the run-in. However, the dreaded combination of Sea Pigeon and John Francome were poised to strike, as can be seen from the inset photograph. At their brilliant best they swept past yards from the line, Pollardstown having run the race of his life to snatch back second place.

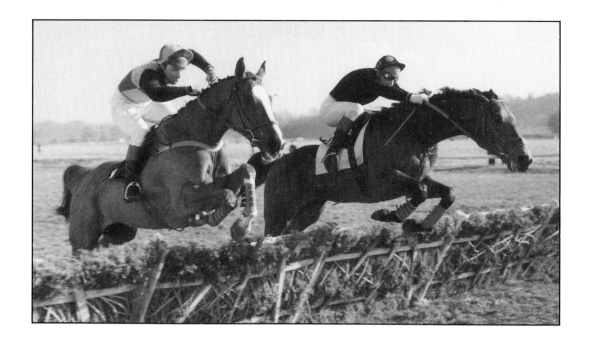

John Francome on Ballyfin Lake and myself on Lighter jump the last in the Philip Cornes Saddle of Gold Final at Newbury. At the line we were decisive winners after a long drawn out struggle.

and paid more attention when they started to issue warning signs.

On the whole, my first season riding for Stan went fairly well, although at that stage no outstanding horses had emerged from the Mellor camp. This soon changed when a horse called Pollardstown competed at Ascot in a three-year-old hurdle race. Stan had bought Pollardstown from Ireland, where he had a reputation for toughness and had been running on the flat the previous summer. At the races I met the horse's co-owners, Richard and Beverley Formby and Bill and Georgiana Tulloch. They had brought along with them a huge entourage of camp-followers who became known as "rent-a-crowd". It was a competitive race with twenty-one runners and, since this was the horse's first experience over hurdles, my instructions were to give him plenty of light. That meant going round the outside to provide the horse with a pleasant introduction and not to be too hard on him under any circumstances. In the event, I lost so much ground going round the outside, I felt as though I had gone via Bracknell. Pollardstown finished like a train in third place, beaten by two lengths in a good field. When I got home that evening I told Sue we would win the Triumph Hurdle – the four-year-old hurdlers' championship run at the Cheltenham Festival in March. The next time the horse ran was at Newbury and he confirmed my high opinion of him by bolting in. It produced the first of my many experiences of the Tulloch brand of celebration. The Tullochs are the very best type of

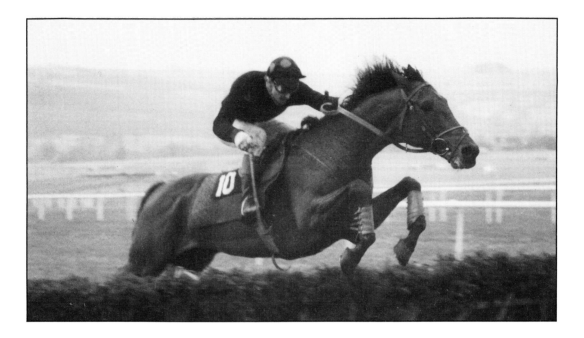

owners to train or ride for. Enthusiasts to the last, when they win they love to share their triumph with all their friends, equally, when they lose they are completely philosophical about it, putting it down to fate. "Rent-a-crowd" has had plenty to celebrate in the last few years. Pollardstown heralded a golden era for the Tulloch horses. Mahogany and then Creag-an-Sgor were two flat-race horses bought relatively inexpensively by trainer Charlie Nelson, but, amazingly, both of them subsequently won "group" races. Since then Lean Ar Aghaidh (whom Georgiana calls "Lean-on-the-Aga") has finished third in the National and then gone on to win the Whitbread in the same year.

I had yet to ride a winner at the Cheltenham Festival and so I was excited at the prospect of partnering Pollardstown in the Triumph. We were convinced his success depended on good ground, so we were thrown into the deepest gloom when it rained ceaselessly for the fortnight before Cheltenham, turning the going into a quagmire. Because of this, I regarded my best chance of riding a winner at the Festival to be a horse called Lighter, trained by John Edwards. John has a good record at Cheltenham and always manages to go home with a winner or two under his belt. Lighter had won the Philip Cornes Saddle of Gold Final at Newbury the previous season from John Francome on Ballyfin Lake. I was, in fact, particularly pleased to win this race, since it evened the score with John, who had played a trick on me

Lighter jumps the last in the 1979 Waterford Crystal Stayers' Hurdle at Cheltenham, my first festival winner.

some weeks before. John is a great friend, but he is a wicked practical joker. At the previous Newbury meeting I had been making the running in a handicap hurdle on one of Stan's horses. We were going a good, fast gallop, as I knew that my horse would at least stay. Turning out of the back straight, I increased the tempo and set sail for home. Just then, another runner loomed upsides me. Suddenly, I felt a hand reach from behind and grab me in what I can only describe as an uncompromising manner. The vice-like grip was not only embarrassing but extremely dis-orientating. I yelled and looked across at Francome, who wore a huge grin. "Get out of that one, Phil!", he shouted as I wriggled helplessly, pleading loudly to be released. We were now in the home straight and really travel-ling. Three strides from the third flight of hurdles from home I thought to myself desperately, "He must let go now". John waited until we were actually in the air before releasing me. Then he started to drop back and at the last hurdle I thought I had the race sewn up, despite John's antics, as we were well clear. Ten yards from the line something flew past me with a wet sail and beat us by a short head. I had a serious sense-of-humour failure when I realised who it was that had touched us off on the line. It was J. Francome, of course.

I broke my duck at the 1979 Cheltenham Festival when Lighter won the Waterford Crystal Stayers' Hurdle for me on the first day. My hopes for Pollardstown in the Triumph the following day, however, were not particu-larly high, as the ground was bottomless. Later, I was to ride another up-and-coming star from Stan Mellor's stable, Royal Mail, in the Cheltenham Gold Cup. Stan and I walked the course on Gold Cup day and he was in two minds as to whether he should withdraw Pollardstown. In the end, he decided to let him take his chance and by the time the field of twenty-eight runners had jumped the second and were passing the stands for the first time, I knew he had made the right decision. The Triumph Hurdle is prob-ably the most competitive race of the season. There is always the maximum number of runners allowed within the safety limit, so a large competitive field is guaranteed and a fair amount of luck is needed to obtain a clear run. Pollardstown handled the heavy ground well and we had a perfect run up the inside to win by two and a half lengths. Two races later, Royal Mail ran a great race in a blizzard to finish second (albeit a lucky one, as Tied Cottage had fallen at the last) in the Gold Cup. I finished the Festival as joint leading jockey with Dessy Hughes.

That summer I received from the Tullochs and the Formbys my first big commission – Pollardstown, naturally.

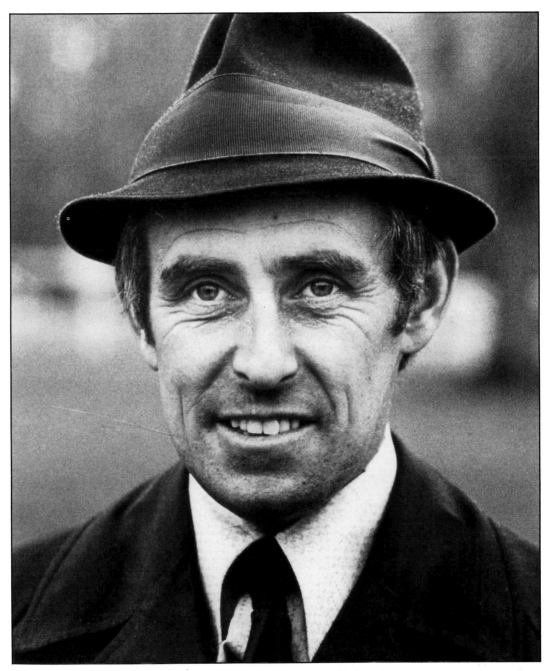

The legendary Stan Mellor. I was lucky enough to know him as a fellow jockey and also to ride for him as first retainer for five years.

Brian Fletcher on Red Rum and Tommy Carberry on L'Escargot
jump upsides in the 1975 Grand National. L'Escargot
went on to win, bringing about Red Rum's first defeat in a Grand National.

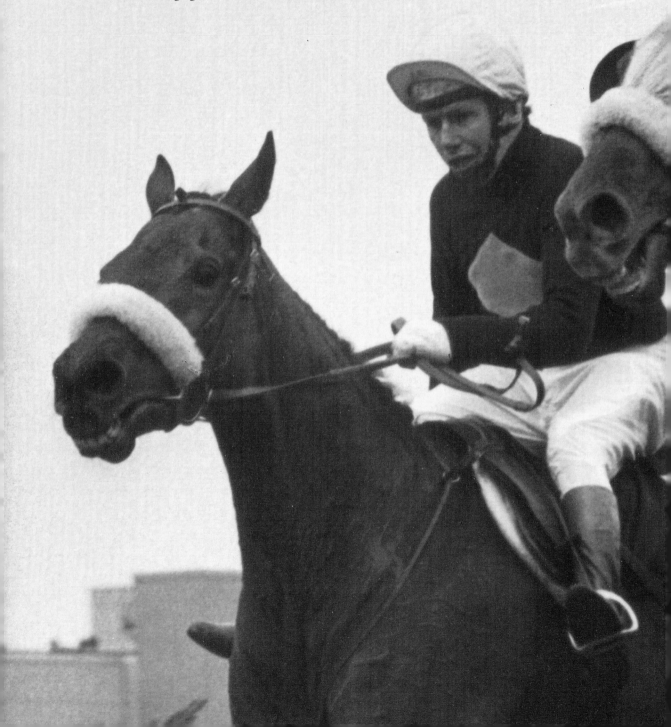

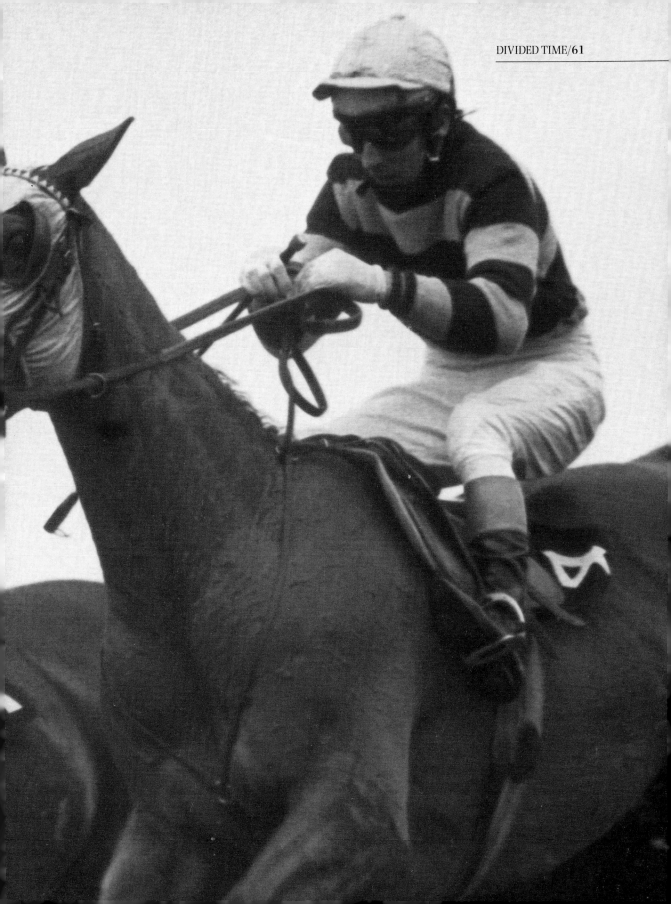

Chapter Five

A UNIQUE SUBJECT

THROUGHOUT MY RATHER mixed riding career in the 'seventies, Red Rum was becoming nothing short of a legend. In the years between 1973 and his retirement in 1978 at the age of thirteen, he had notched up three Grand National wins and had twice finished second. As the man chosen to immortalise this remarkable horse in bronze, I decided I should become as familiar as possible with him, so I set about delving further into his background.

The first striking point about him was his breeding. For a horse that has won three Grand Nationals, his pedigree makes a joke of the stud book. Born and bred in Ireland, Red Rum is by Quorum, a miler who produced mainly sprinters, out of a mare called Mared by the five-furlong horse Magic Red. She managed to win one race over seven furlongs before being despatched to stud.

As a yearling, Red Rum was sent to Goffs Bloodstock Sales in Ireland, where he was sold for four hundred guineas to Tim Molony, who trained in Leicestershire. The horse's first owner in England was a man called Maurice Kingsley for whom, coincidentally, I was to ride years later when he had a couple of horses in training with Stan. His modest intention was to buy a horse that could win the two-year-old selling race at Aintree the following April. In 1967 Red Rum opened his account by dead-heating in that race.

No one could ever have predicted that his first unremarkable victory on the flat would be superseded by an unparalleled victory in a totally different role competing in the most gruelling race of all.

Red Rum was retained by Tim Molony after the seller and won two more small races on the flat for him before being sold to go jumping in 1968. He moved to Malton in Yorkshire where he was trained by Bobby Renton and owned by Mrs Brotherton. When Renton retired Red Rum remained in the same stables, trained first by the jockey, Tommy Stack, who had briefly taken out a trainer's licence, and then by Anthony Gillam. In 1972 Mrs Brotherton decided to sell Red Rum and sent him to the Doncaster Sales. Ironically, she had been trying to find a horse to win another National since Freebooter won the big race for her in 1950 some eighteen years before. Clearly she considered that Red Rum would not be

Tommy Stack raises his arm in jubilation as Red Rum completes the hat trick in the 1977 Grand National.

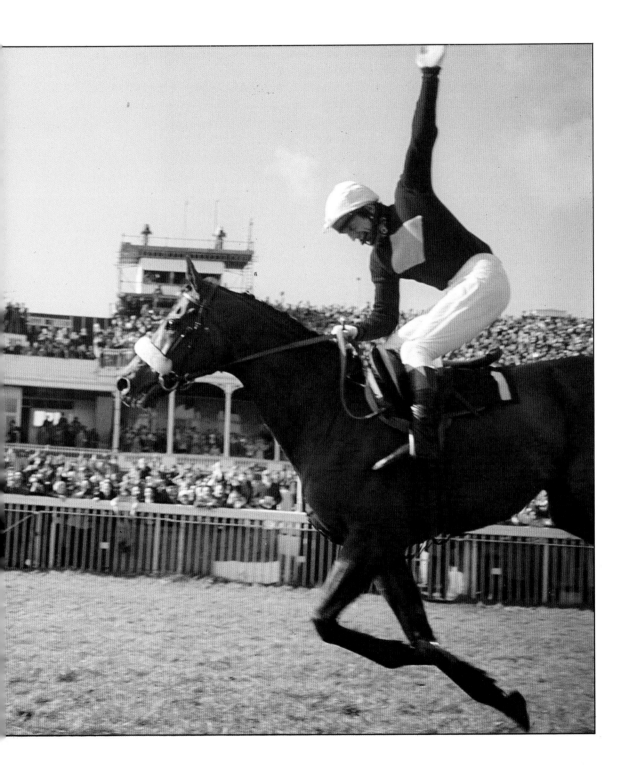

the one to make the grade, despite the fact that the horse had now notched up some useful form. He went to the sales with three hurdle races and five chases to his credit, but these were won in the north, where the standard of racing was not, perhaps, as high as on the southern tracks.

It was at this point that Donald "Ginger" McCain entered the picture. He was a former taxi-driver and second-hand car dealer who had begun training a small string behind his garage in Southport. The most he had ever spent on a horse up until then was a thousand pounds, but he had just received an order from eighty-five-year-old Noel Le Mare to go out and buy him a Grand National horse. Ginger thought that Red Rum would be right for the job – the horse had good recent form and stamina, was qualified for the National and was obviously thoroughly genuine. With the £7,000 Ginger was authorised to spend, he believed he might just secure him. Bidding was brisk up to £5,500 and then Ginger slipped in a bid of £6,000: Red Rum was his. Ginger was aware that the horse was "a bit footy", but was dismayed to find that Red Rum was actually lame after his arrival at Southport. With resignation Ginger told the lad to take him into the sea for half an hour. Ginger does not claim that this was a miracle cure, but from that day on Red Rum never suffered from foot trouble again. It was an amazing piece of luck that Red Rum ended up at that particular stable because he had been recently diagnosed as having pedal ostitis. Ginger was the only man in the country who trained on a beach and the perfect going provided by the harrowed sands was ideal for Red Rum's feet. If he had continued to be trained on conventional gallops it is possible that his feet would not have withstood the strain.

Red Rum's story has been well chronicled elsewhere, however, I think it is worth reminding ourselves just how this flat-bred horse triumphed against all odds. Most jumpers spend the first three or four years of their life out in a field, so they have sufficient time to mature. Red Rum, on the other hand, had been on the racecourse since he was a two-year-old and had endured enough racing to have soured most horses as well as having foot trouble. So Ginger McCain's part in training Red Rum cannot be under-estimated: the improvement brought about by the horse's transfer to his care was obvious from the start. Even without winning the 1973 Grand National, Red Rum's first season at Southport saw him triumph in his first five races on the trot and complete the season without finishing out of the first three.

The following November, Red Rum and I met for the second time. He was running in the Hennessy Gold Cup at Newbury and I was again partnering Spanish Steps. Red Rum had already achieved three wins in the

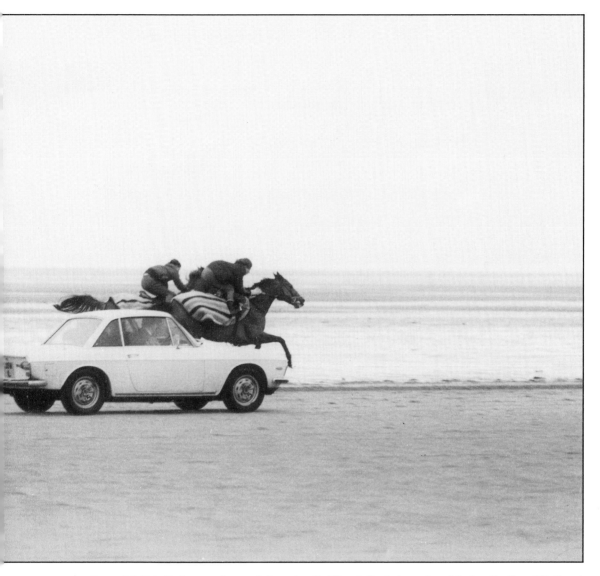

Ginger McCain finds a novel way of observing Red Rum's final piece of work before the Grand National.

new campaign, so he came to the race extremely fit. The Hennessy is one of the top three-mile handicap chases in the racing calendar and it was a measure of the improvement in the horse that he was only just caught in the last few strides by Red Candle who was carrying a stone less than him. For me, the race was a disappointment. Spanish Steps, who started at six-to-one, second favourite, finished down the field. After the race we had no bad luck stories – we were just not good enough.

For the 1974 Grand National, Red Rum's weight had soared from the 10st 5lb of the previous year to 12st. I was not offered a ride in the race that year and I had to content myself with watching the drama unfold on a television at Ascot, where I was riding in the Heinz Steeplechase. This now defunct race was the only steeplechase on an otherwise flat race card. That day was memorable to me if only for the carnage created in the race at Ascot. There were countless fallers, and the track resembled a battlefield. The unluckiest victim was Ron Atkins who, having hit the deck half-way down the back-straight, was slowly making his way back nursing a broken nose. With every ambulance heavily involved with other casualties, he set off across the centre of the course on foot, eventually ducking under the rails to cross by the winning post. Unfortunately he was so involved in diagnosing the damage to his nose that he failed to see the horse, which a few moments earlier had deposited him on the ground, careering up the course in his direction, clearly intent on finishing the job. Seconds later, half a ton of horseflesh bore down on him, laying him out cold on the Ascot turf. The flat race jockeys viewed the procession of hospital-bound stretchers with incredulity and I was forced to agree with Willie Carson when he remarked that he thought we were all completely mad.

Anyway back at Aintree Red Rum had started at eleven-to-one, third favourite because of his extra pounds, but he still made his task look incredibly easy. Totally at home on the fast surface, he cruised to the front at Bechers on the second circuit. From then on he never looked like being headed and he won so easily that his jockey, Brian Fletcher, felt confident enough to salute the crowd and ease the horse up before the winning post. He won by seven lengths from L'Escargot. It was a staggering performance under top weight. Moreover Red Rum recovered so quickly from his exertions that within two days he was behaving as if he had not been competing at all. So Ginger decided, against all standard training procedure, to run him in the Scottish Grand National. It is generally felt that horses which have run in the National have undergone such a gruelling experience that all they are fit for in the next few months is a long rest in a field. Red Rum was the exception. He not only ran in the four-mile Scottish Grand

National at Ayr twenty-one days after his Aintree victory, but he also won it convincingly.

The following year Tommy Carberry and L'Escargot took their revenge. With a top weight of 12st, Red Rum led the field five fences from home, only to be overhauled by L'Escargot on the run-in carrying 11st 3lb. Back in third place came Bill Smith on good old Spanish Steps who was improving his fourth place position of the previous two years. I rode a horse by the name of Kilmore Boy, trained by Alan Jarvis. Despite my misgivings about his size (he felt like a rabbit when I was on his back), he gave me a great ride before tiring very quickly and then falling six fences from home.

The 1976 Grand National saw a jockey change for Red Rum. The racing world was taken aback when Brian Fletcher, the horse's partner since his arrival at Southport, was replaced by Tommy Stack, the man who had briefly trained the horse in his younger days. Red Rum had by now clearly lost much of his speed on the park courses and a disagreement over tactics precipitated this jockey change. The horse arrived for the National without a win that season and the opinion circulating round the pundits was that he was past his best. As it transpired, he led as he approached the last fence, before being headed on the run-in and beaten by Rag Trade by two lengths. Ironically back in third place was Brian Fletcher on Eyecatcher. By now it was apparent that however good or bad Red Rum's form away from Aintree was, at Aintree he was a phenomenon and could never be discounted.

Despite some indifferent form leading up to the 1977 National, he started the race at nine-to-one, second favourite. The much-fancied Andy Pandy was favourite and had been let in at the advantageous weight of 10st 7lb. I was riding a sixty-six-to-one outsider called Happy Ranger, trained by John Thorne. Approaching Bechers for the second time, I really thought we were in with a chance as my horse was belying his odds and running a great race. Then, out in front, Andy Pandy fell at Bechers, leaving the formidable Red Rum in front. From then on it was a procession. Red Rum gradually increased his lead to win by twenty-five lengths under Tommy Stack. My chance had gone six fences from home when Happy Ranger began to find the race too gruelling and weakened to finish seventh. One of my trainers, John Edwards, who was also an accomplished amateur rider, had in a rather rash moment decided to ride his Grand National entry himself. High Ken was a good horse, but he was an indifferent jumper and not generally considered to be an Aintree type. John was particularly concerned by a pre-race runner-by-runner analysis in one of the newspapers. In the weighing-room before the race he showed it to me

with a worried air. The journalist had weighed up the chances of each horse in the race. Against High Ken he had simply commented: "Hello High Ken – Goodbye John!" Sadly, his prediction proved correct, but through bad luck more than anything else, as John and High Ken were brought down at the first. From that day on John became known as "Jockey" Edwards.

Red Rum was never to run in the National again. Sadly, his attempt to notch a further victory was snatched from him when an injury to a hind leg forced Ginger McCain to withdraw him at the last moment. Having ridden in the National many times myself, I know that a trouble-free run in the race is an achievement in itself. Leaving aside Red Rum's success rate, his sure-footedness and ability to avoid trouble year after year were amazing. It is interesting to consider the qualities which enabled Red Rum to achieve such success at Aintree. First of all, he always possessed courage and the will to race. Red Rum made it perfectly clear that the Grand National course held no fears for him. Also, every time he jumped round he grew to know the course better. The drops, angles and undulations no longer surprised him in the way that they surprise an Aintree novice. Red Rum undoubtedly had stamina, the ability to keep galloping relentlessly, but the amount of effort put into jumping those fences was crucial. Any little mistake will sap a horse's energy. The accuracy and care of Red Rum's jumping enabled him to conserve his energy and cover the immense distance in the most efficient way possible. Clearly he revelled in tackling the Aintree fences. Red Rum's unique combination of skills enabled him to dominate the Grand National for five glorious years and it is doubtful if this achievement will ever be bettered.

Chapter Six

SCALING UP

HAVING ESTABLISHED THE concept of the statue, I now set about developing my idea in three dimensions. Working on a small model about eleven inches high I experimented with various subtle changes from the basic pose. By bending the armatures and moulding the clay, I eventually found a position which was aesthetically pleasing and which took on a romantic flavour. Whilst modelling, I tried to look at the piece not as a work in its own right but as a life-sized statue which had been reduced in size. I kept asking myself whether it would work on a large scale, and I was fully aware that any weakness in design which might be overlooked on a small scale would be glaringly obvious once the statue had attained life-size proportions. I decided that it would be safer to make three models in all. It was too risky to work directly from the small model when creating the life-size. I concluded that a working maquette, exactly one-third of the ultimate size, would allow me to study the exact pose, anatomy and form of the sculpture. Hopefully it would also enable me to pick out and correct all the inevitable problems on the smaller scale which would prove catastrophic if overlooked until the final stages.

I was determined, if at all possible, to avoid having to make huge changes to the statue because of a badly thought out design. Before going any further, I paid another visit to Southport to see the old horse again. Up until now, I had merely taken in the essence of Red Rum. His physique, his spirit and his exuberance had given me plenty of scope for interpretation and I had formed a general idea for the composition. Now I had to get down to the "nitty-gritty" and study the horse anatomically. Unlike some subjects, Red Rum co-operated fully. I took seventy or eighty measurements of the horse and jotted them down, with notes of his physical peculiarities, before making some small sketches. I also used up a couple of reels of film taking photographs of him from every conceivable angle. On returning home to my studio I studied the data I had accumulated. In my notebook I had scribbled brief reminders of the horse's anatomy. From my point of view it was a piece of luck that Red Rum was bred to be a sprinter. With the powerful and compact physique of a horse built for speed rather than for stamina, his rounded frame ideally lends itself to sculpture. It still amazes me that a horse of his pedigree could defy nature and turn out to

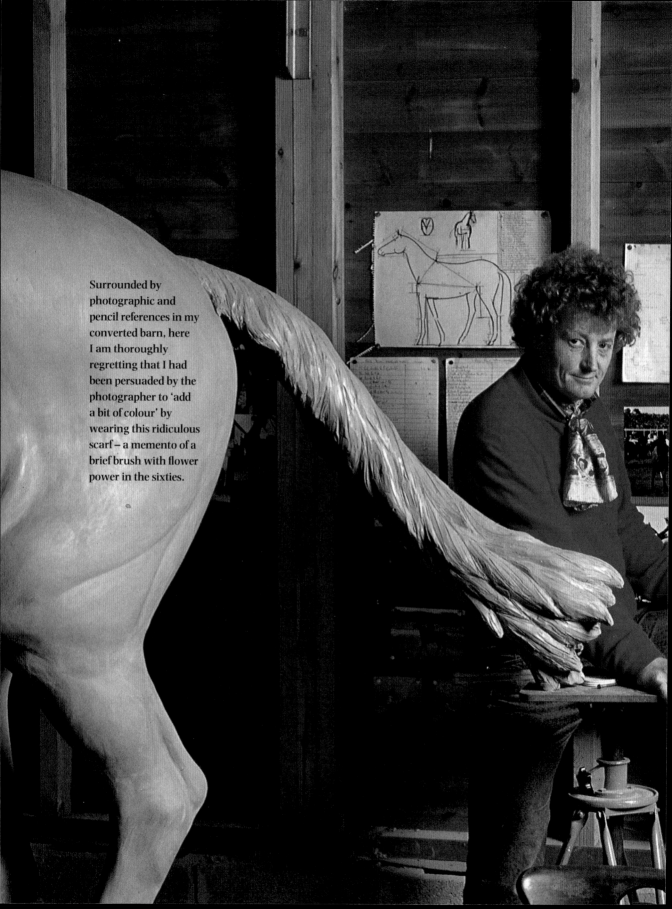

Surrounded by photographic and pencil references in my converted barn, here I am thoroughly regretting that I had been persuaded by the photographer to 'add a bit of colour' by wearing this ridiculous scarf – a memento of a brief brush with flower power in the sixties.

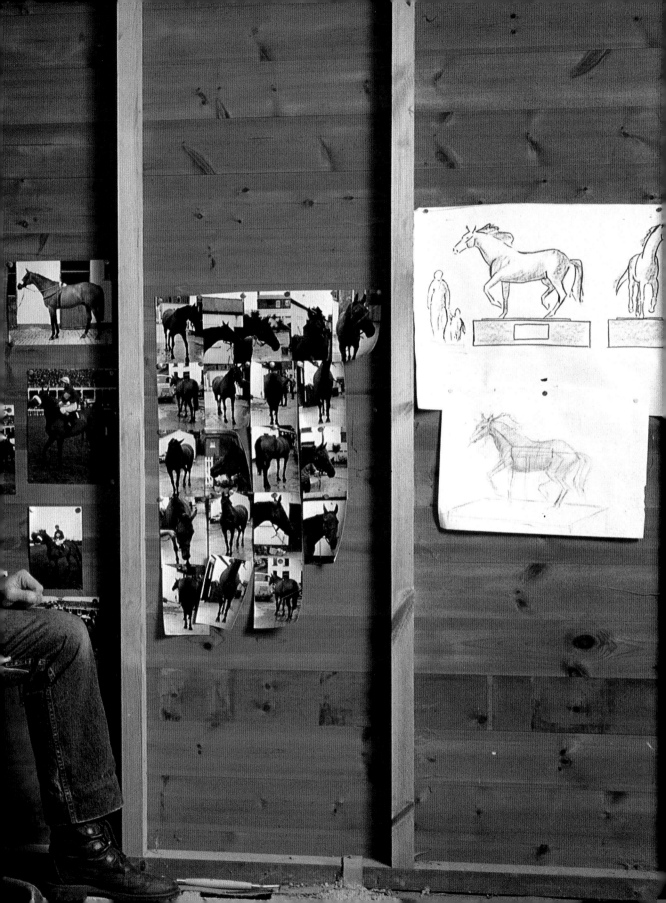

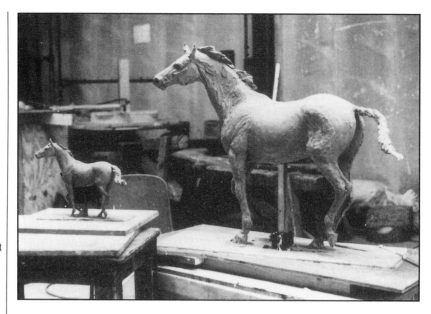

The original model next to the unfinished one third life size working maquette.

possess limitless stamina and jumping ability. However, I was just content and delighted that the triple Grand National winner's conformation contrasted starkly with the usual shape of the average chaser which, from a sculptor's point of view, is less appealing. Red Rum possesses a powerful flat-racing frame with a classy head. Furthermore, to help my task to an even greater extent, he has a distinctive character. Individuality in a subject is very important if one is to capture a good likeness.

Since I had never before attempted a work on a life-sized scale, there were times when I was seized with apprehension about the project. Although I had a pretty good idea in my own mind how to set about it, there were moments when I inevitably wondered if I had bitten off more than I could chew. As is so often the case with me, I would swing from one extreme to the other: brimming with confidence one day, the next lying awake at night in a cold sweat, worrying about armatures or what materials to use. I decided to seek help and advice. This I came across in the form of Alma Boyes, whom I met on a visit to the Morris Singer Foundry, the firm which I had selected to cast the statue. As well as teaching sculpture and ceramics at several art schools around the country, Alma works occasionally for Morris Singer. It is possible to deliver a maquette to the foundry and sit back while the work is scaled up mechanically to the required proportions. I was determined not to resort to such measures, as I felt the result would no longer be all my own work. I also wanted to have complete control over

every stage of the process. However, I did think that at the scaling up and roughing out stages, Alma's expertise would be invaluable. If the project was to reach a successful conclusion, the statue had to be treated as a unique creation, not just as an enlargement of a maquette. Although all the measurements would be taken from the maquette, I wanted to have the freedom to develop the statue as it progressed, perhaps changing things here and there where necessary. Only then would the sculpture attain a life of its own. A small work, mechanically scaled up, would, I feared, lack impact and be flat and uninteresting.

In building a large sculpture it is not enough to model directly onto the armature as would be done on a small scale. The torso and main body have to be built up to within about an inch of the finished dimensions. This provides a solid base on which to apply the modelling material. Clay or plasticine have no tensile strength and cannot support themselves on the armature alone, so the building up or "roughing out" process is required. There are several ways of doing this and I originally intended to use the traditional method of chicken-wire and plaster. However, Alma had recently developed a radical new method of roughing out which involved polystyrene foam. Not entirely convinced that it was the right medium for me, I decided to experiment with the foam when we were roughing out the one-third life-size to see if I could get along with it.

I had built the small model without any particular regard to scale or measurements, working purely from eye. So the first task was to establish its exact scale in relation to the life-size. From my measurements of Red Rum we calculated that we would have to scale up the model 2.7 times to make a maquette which was exactly one-third the size of the horse. This might seem a rather cumbersome and complicated system; it would appear far simpler merely to reduce my measurements of the horse by two-thirds to find the right scale. However, I wanted to stick as near as possible to my original concept and make changes only when strictly necessary. I also regarded this process as a dummy-run for the big one and I wanted to go through the armature and "roughing out" process in exactly the same way as we would for the life-size. The function of the original model had been to establish the overall concept and emotional feel of the statue and so I hadn't needed to cross-check its proportions with those of Red Rum. This presented me with a dilemma. On scaling up, we were faced with two sets of measurements – those of the small model and those of the horse himself. I decided the best way would be to scale up from the model, checking as we did so that the measurements corresponded, within a small margin for error, with those of the horse. Of course these could form no

more than a rough guide, as the planned sculpture would portray the horse in an active pose, whereas I had taken my measurements from Red Rum in a passive position. This would inevitably create some distortion. To my surprise, the proportions of the model corresponded almost exactly with the horse's measurements; thus, what looked at first to be a complication became an advantage for cross-checking purposes.

Alma is ingenious at scaling up and I soon realised that my own proposed crude method would soon have landed me in all sorts of trouble. Onto the base of the original we drew a ground plan in the form of a grid. Then onto the base of the proposed sculpture we drew a duplicate, scaled up 2.7 times. From every joint or high point on the model we took measurements, dropping a plumb-line to the ground-plan and marking with crosses the exact positions and height. Having checked and rechecked our measure-ments on the model, we then set about multiplying them 2.7 times and transferring them onto the scaled up ground plan. To the centre of the base we bolted a one-inch square aluminium T-shaped bar with half-inch holes drilled along the horizontal part. This would be the main support and back-bone of the structure. Next, we passed half-inch aluminium wire through the holes, from which we would make the basic skeleton. Having secured the wire to the main support, we set about bending the armature to the correct shape whilst referring constantly to the ground plan and small model for guidance. Every joint had to correspond to the markings on the grid. Once we were satisfied with the fairly elaborate armature, the roughing out process had to begin. This I found intriguing, since it was my first encounter with polystyrene foam. The scale of the one-third life-size barely justified the use of it, but it was my only chance to practise with the stuff before I committed myself irrevocably to using it on the life-size. Polystyrene foam is created by mixing two chemicals which react with each other, making a volatile substance that expands dramatically to thirty times its original volume and sets within seconds. Because of its rapid expansion it can be difficult to control and there is also a tendency to mix too much. The aim is to pour the foam round the armature so that it is completely encased. Once set, the foam stabilises completely, making the model very strong and light, but clearly something has to contain the frothing substance as it goes about its metamorphosis. Since the foam has to be applied in stages, each section of the armature is, in turn, loosely wrapped in polythene which is sealed at the top, except for an opening through which the foam can be poured. As the foam begins to expand, it stretches the polythene tight and this can be cut away when the foam is set.

Once the torso, neck, head and upper legs were surrounded with foam

we stood back to assess the work. Alma had warned me that this would be the worst point and, quite frankly, I was pretty horrified. It looked a complete mess. Somewhere inside that shapeless mass was our armature. The first thing we had to do was to locate from the ground plan the joints of the armature and to mark their positions with a felt-tipped pen on the surface. Then we started to carve the foam back to the shape we wanted, whilst constantly reassessing the armature so that we didn't take off too much. We sliced great chunks off the body with hacksaws and rasps, eventually shedding about seventy-five per cent of the original foam. At this stage I was worried that the carving process was alien to the concept and would produce a monumental and static effect. My concern was that the foam would prevent me from gaining the flexibility and delicacy I needed. However, gradually the model began to take shape and to take on the loose and relaxed impression I desired. By the time we had finished roughing out I had been converted to polystyrene foam as a medium. We carved and rasped it back to within approximately half an inch below the planned finished surface and completed the process by applying a layer of scrim (coarse sacking dipped in plaster) and two coats of shellac to seal it. I now had a good solid base on which to start modelling.

I decided to use plasticine on the one-third model, because it was a material more familiar to me and I found it more convenient than clay. As I modelled, I began to make small improvements and refinements, perhaps tilting the head up slightly more, moving a leg a fraction one way or the other or making a minute adjustment to the angle of the tail. All these decisions were relatively straightforward at this scale.

Eventually the one-third model was finished and I was satisfied with the result. At last I felt I was ready to tackle the large one. Many lessons had been learned, and I still felt there were improvements to be made at the last stage, but now the rehearsal was over and I was prepared. All the experience I had acquired in the past few months, and all my energy for the next few, had to be injected single-mindedly into the creation of a sculpture that would do justice to Red Rum, to my patron, Seagram, and to myself; I intended to create a piece with which we would all be proud to be associated. In my mind's eye I had formed a picture of the statue in its finished state and I dreaded the thought of the reality not fulfilling the dream. This was the challenge – to achieve all that I had promised. To Seagram I had exuded a confidence I didn't always feel, and now I had to deliver the goods.

Chapter Seven

ROUGHING OUT

AS I EMBARKED ON the making of the life-sized statue of Red Rum I once again recruited the valuable help of Alma for the scaling up of the armature and for the roughing out stages. We decided to do this work at the foundry where all the facilities were on hand. We anticipated it would be approximately one month before I could transport the piece home and complete the modelling. With this in mind I had recently converted my barn, since my regular studio was too small.

Once we had calculated from the maquette the precise dimensions of the new armature, we arranged for the foundry to make up the pieces to specification in advance. On the first day, I arrived early to find Alma already beginning to sort out the pile of assorted aluminium rods and bars. In the middle of the workshop annexed to the foundry, where we were to spend the next month, stood the large six feet by four feet chipboard base onto which our structure would be secured. Bit by bit we erected the armature. In the centre was a four-inch square main support in the shape of a large "T" and, as before, we had drawn the scaled-up ground plan onto the base and transferred the measurements of the relative positions of the joints and high-points. By combining the use of the plumb-line and measurements we could determine the exact position of each section of the structure. We placed the two shoulder sections, which were constructed of two-inch square aluminium bars, to the front of the "T". Onto these went a piece of one-inch square aluminium, running from the point of the shoulder to the elbow, and then another piece down to the knee, and so on. Every section had a joint for attachment at either end. Some sections articulated up and down, while others needed a ball-and-socket joint. As one section was married up to another, the newly joined piece had to be checked to ensure that the angle and height had not somehow shifted. Any section out of place in the structure would automatically throw all the pieces below it out. It reminded me of a child's puzzle, the sort in which several little coloured balls inside a flat container have to be manoeuvred into their respective holes by tilting the container in various directions. The act of getting one ball into its hole makes another one fall out. We were similarly frustrated: if we aligned the hip to stifle section correctly, some other piece connected to it would be thrown out of true. Eventually,

Top: The finished maquette now cast into plaster stands in front of the future life-sized study of Red Rum. Not much resemblance so far!

Bottom: The Old English sheepdog stage – but I persevere with the powered hack-saw.

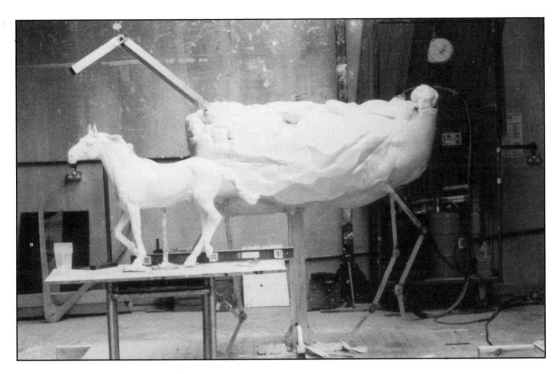

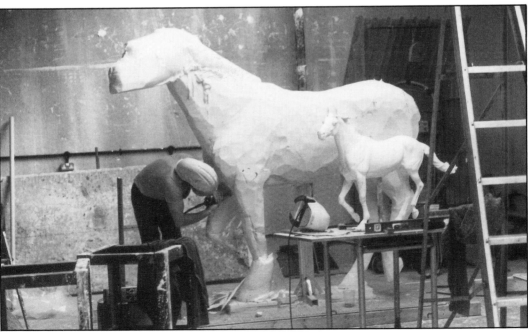

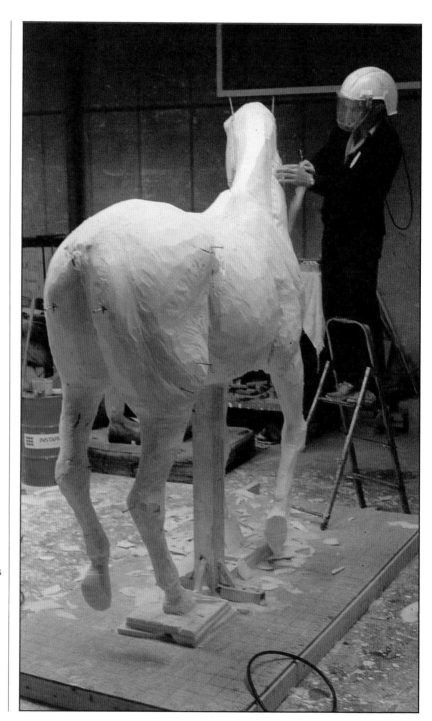

The statue begins to take shape. On the base is the ground plan from which we took our measurements.

Opposite, top: The roughing out process is completed. The statue acquired a simplicity which really appealed to me.

Bottom: Having covered the foam in plaster scrim, Alma and I feel able to relax.

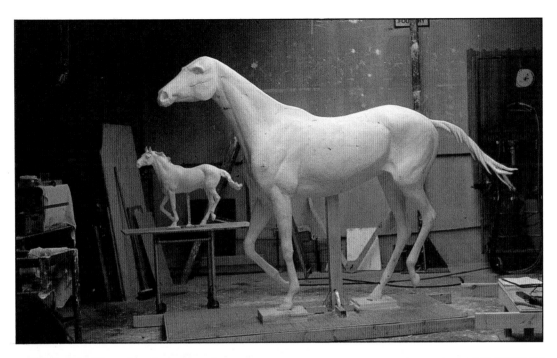

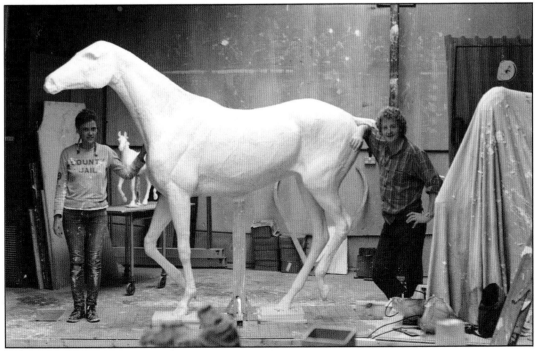

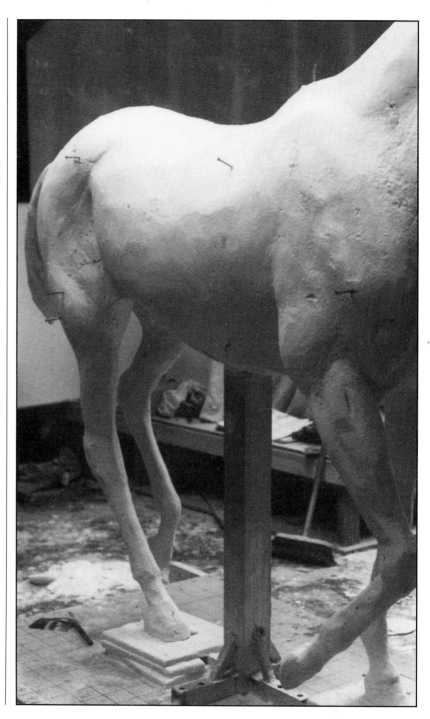

The tail has been added here, and nails protrude from the foam at various points. These mark the exact position of the joints in the armature and act as a guide. The nails had to be checked and re-located constantly as we reduced the overall mass.

however, after much patient adjustment and co-ordination, the armature was ready.

We would be using a lot of polystyrene foam this time, so instead of mixing the chemicals by hand, the foundry provided us with a gun which was attached to two barrels of liquid foam. This gun automatically mixed and fired the substance out of the nozzle when the trigger was pulled. As with the one-third model, first we surrounded the top of the "T" of the main support with polythene, which we sealed at the top. Then we pointed the foam-gun inside the bag and fired the bubbling substance into it. After a few hours the torso was engulfed. Before moving on to the next section we carved the foam back roughly to achieve the correct shape, constantly re-establishing the armature via the ground plan and marking its position on the foam. This became a constant and essential task, as in the huge volume of swollen polystyrene it would have been very easy to lose our way completely. The process of first wrapping and then firing in the foam continued, before finally the polythene was removed and we could hack back to the basic shape. For the best part of a week we followed this pattern until the entire armature was covered in polystyrene foam. For the roughing out, the foundry had provided us with a hack-saw, which was connected to a power-line and this greatly eased our task. Even so, the huge chunks of foam that had to be cut away from the model made for hard and dusty work. Polystyrene foam dust is damaging to the lungs, so during carving or rasping, special air-purifying helmets had to be worn which, apart from emitting an irritating buzz which precludes any conversation, became increasingly uncomfortable as the day wore on.

As the work on the model progressed I refused to allow myself to become despondent with its development, as I knew from my previous experience that there would be a phase when the statue would look clumsy and as far removed from my original concept as could possibly be imagined. When it began to take on the appearance of a huge and grotesque Old English sheepdog unfortunately my good intentions foundered and I could no longer contain my depression. Would I ever be able to capture the vitality and spontaneity that was absolutely essential to the work? Alma seemed unruffled throughout, and if beneath that calm exterior she harboured a few doubts, she kept them to herself. Alma has a great sense of humour and whenever I was having one of my more severe bouts of dejection she would dispel it with one of her casual, crushing remarks which reduced us to fits of giggles. Alma is an interesting mixture. She has a healthy lack of respect for arty types and was one of the original punks – still retaining her Doc Marten boots which give substance to her slight frame and prove

helpful when she is single-handedly knocking down the walls of her flat.

Although working with polystyrene foam was a messy business, there were definite advantages to foam as a carving medium. First and foremost, if you accidentally removed too much it could simply be replaced, and secondly, despite its strength, it was light and easily carved away. As the statue began to fine down to manageable proportions, we added little bits here and there, then carved them back again to keep the whole model at the same stage of progression. This is always important but on a large scale it is that much harder to do. Alma and I found the best way to ensure continuity was for us to work at opposite ends or sides for a while, and then swap over every so often. One day I realised we had made a break-through: the roughed out horse at last began to have the impact and mood that the final statue, I hoped, would exude. If it didn't, no amount of modelling could disguise that failure.

As we gradually approached the finished surface, we dispensed with the cruder tools and began a more subtle fining down action with rasps. The statue began to take on simple sculpted lines which I found very exciting. The horse had come alive and the lack of detail made it even more striking. Here stood the fundamental Red Rum, unrecognisable, of course, as any skeleton would be, but just as real. Once we had rasped and sanded the foam down to the exact proportions, the final process was to add plaster and scrim. This not only strengthens the structure but also provides a firm base for modelling, as the foam itself would be far too crumbly for the purpose. With that, the roughing out stage was complete and I was thrilled with the result. Before me stood my sculpture, looking like a horse skinned and stripped but still possessing an elegance and life I had only dared to hope for. The challenge now was to add, with delicacy and perception, all the external parts – the eyes, the nostrils, the muscles, etc. – all those naturally sculptural features that make the thoroughbred racehorse such a beautiful animal. Although this could not be just any thoroughbred racehorse: this had to be indisputedly the image of the great Red Rum.

Chapter Eight

MAKING THE BREAK

TO RECREATE RED RUM satisfactorily, I came to the conclusion that I needed a final audience with him at my studio in Oxfordshire so that I could work from life. Luckily, Ginger and Beryl McCain were, as usual, accommodating and they agreed to send him down for a few days when I had reached a fairly advanced stage in the modelling. In the meantime, however, for the purpose of anatomical accuracy, I needed a stand-in and this was where my old partner Royal Mail came in.

Royal Mail had been kindly presented to me on his retirement by his owners, Mr and Mrs John Begg. Since the 1979 Cheltenham Gold Cup, Royal Mail and I had had our moments of triumph. At the same event the following year he was lying third but was weakening when he fell four fences from home, bringing down Jack of Trumps and Jonjo O'Neill. In the mêlée Royal Mail sustained a minor fracture to his jaw bone which I assumed would rule him out for the rest of the season. However, he came out of the race so well that Stan reckoned, providing he could adapt the bridle to take the strain off the horse's jaw, he would be able to run in the Whitbread Gold Cup. Curiously, the break had not affected his appetite and he seemed as well as ever. The Whitbread Gold Cup is one of the most valuable handicap chases in the calendar and is run over three miles and five furlongs. I had, in fact, always suspected that two and a half miles was Royal Mail's best distance, as he had plenty of speed and had only weakened towards the end of an extended distance.

As I walked onto the racecourse, the first person I saw was the television commentator, John Oaksey. He informed me that he had tipped Royal Mail in his newspaper column that morning. My reply was, "That's bad luck then, because I don't think he'll get the trip, but don't repeat that on T.V!" Despite my lack of confidence, the race was run to suit Royal Mail to perfection. The first half was conducted at a snail's pace, which turned the race into a sprint finish where speed rather than stamina had the upper hand. Royal Mail gave me one of the best rides in my career and sprinted up the Sandown hill to win by a length. I never rode a horse that jumped the railway fences down the back straight at Sandown with more accuracy. In the unsaddling enclosure, John Oaksey revealed my earlier remarks to the world on T.V. which caused me some embarrassment,

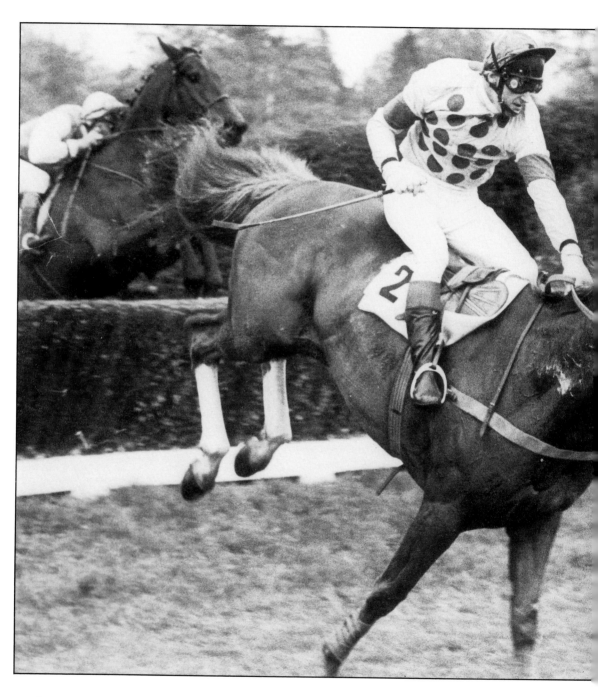

Royal Mail and I jump the last fence in the 1980 Whitbread Gold Cup.

but in the wake of his kind words about my riding I could hardly be cross.

At the beginning of the next season I started to think fairly seriously about making it my last. My work as a sculptor in the summer months was thriving and I knew that the sooner I threw myself into it full time, the better. There was also the question of my weight control which was becoming more of a struggle every season. Another factor was that Stan was reducing his jumping string and turning more attention to flat. Finally, I was nearing the time of life when most jump jockeys start to think about preserving what brains, if any, they have left. A really good season, culminating in Royal Mail finishing a close and unlucky third in the Grand National behind Aldaniti, prompted me to postpone my decision to retire for a year. This was purely so that we could have another crack at the National, which had been snatched from us at the second last. Royal Mail had given me a superb ride and we crept from the rear up the inside to join the leaders going towards Bechers on the second circuit. With three to jump only Aldaniti and Bob Champion were ahead of us. I had been mainly concerned about conserving Royal Mail's stamina and had carefully ridden the horse to save petrol throughout the race. I calculated there was just enough left in the tank if I kept off the throttle until half-way up the run-in. With two lengths to spare between the leader, Aldaniti, and us we approached the second-last. Aldaniti started to run left-handed down the fence, forcing me to switch Royal Mail to his outside only a few strides from the fence. This distraction inevitably caused Royal Mail to make an appalling blunder from which we barely survived and which certainly finished our chances of winning. With the stuffing knocked out of him, Royal Mail was passed on the run-in by the late John Thorne (not to be confused with the trainer, John Thorne, mentioned earlier) and Spartan Missile to finish six lengths behind the winner – a margin I am certain was less than the ground and energy thrown away by our mistake. Next year, I promised myself, definitely my final one, would be different. I would win the National on Royal Mail and would retire on the spot. If only it had happened like that! The reality was rather different.

As if to convince me that I had made the wrong decision in not retiring, my final season featured calamity after catastrophe. After a slow start, a bad fall in a novice chase at Leicester put me out of action for six weeks with a collapsed lung and several broken ribs. I had hardly recovered from that before I was back in hospital with more broken ribs. I thought at least I had used up my bad luck for one season, as long as I was fit for the National, it was all I cared about. On that front all was going well and, having recuperated from my latest injury, I rode Royal Mail in his pre-

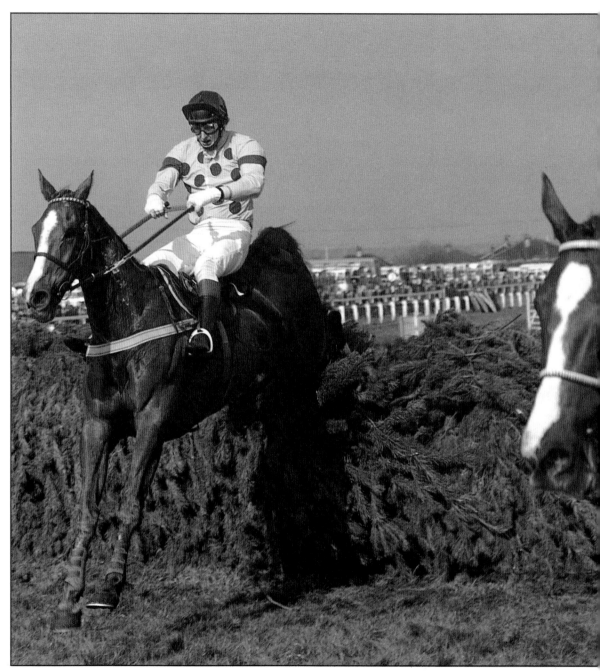

The last in the 1981 National. Aldaniti on the right is in front as Royal Mail gives
his all to get on equal terms after a bad mistake at the second last.

National warm-up race at Doncaster where he won convincingly. This victory installed him as firm anti-post favourite. During the weeks building up to the big race I became preoccupied with keeping myself in one piece. I refused to take part in novice chases and was generally very selective about my rides. This would be my tenth and last chance to win the National and I was not going to blow it through injury. John Edwards had booked me to ride Broomy Bank in the Topham Trophy on the first day of the Aintree meeting. The horse was a good, safe jumper who was also favourite for the race. On the way up to Liverpool I decided that after the Topham I would take the next day, Friday, off so that I could rest and be fit for Saturday. Broomy Bank ran disappointingly in the race, having struggled the whole way, I told John afterwards I would not be going to Ludlow to ride his two runners. I did in fact have three rides booked, but the one in the last race of the day was not trained by him. However, after racing he encouraged me with a couple of glasses of champagne and I soon relented. The following day found me hurtling round baked hard Ludlow. With the two Edwards' runners out of the way, I only had one ride left before I could head off with relief back to my hotel at Southport. My mount had previously given me some enjoyable rides on soft ground but it was instantly clear that he could not cope with the fast conditions and this caused him to make some hair-raising errors. As we landed over the second-last, out of contention, I congratulated myself, "Thank God – I've made it." My next conscious thought came on waking up in the ambulance room. I looked across to the bed next to me and saw another jockey, Charlie Mann. "Tell me it's not the National tomorrow", I said, "I'm afraid it is", he replied.

A fall at the last had knocked me out cold for about ten minutes. Even if I could have ridden the following day, which I certainly couldn't, concussion automatically ruled me out for the next seven days and, to cap it all, I had cracked my shoulder blade. After a night in hospital, feeling ill and utterly dejected, I was in an extremely bad humour in the morning and the luck-less patient who unwittingly asked me if I wanted to take part in a Grand National sweepstake was left in no doubt about what he could do with it. Still suffering from concussion, I was collected by my brother-in-law from hospital and driven home. On the way back I listened to the National on the car radio with a dreamlike detachment bordering on numbness. Through the wind rushing past my open window I heard a far-off and distant voice intoning, "And Royal Mail's gone! Royal Mail's down at Bechers!", but I felt absolutely nothing.

Chapter Nine

WORKING FROM LIFE

ON THAT RATHER ignominious note I effectively ended my riding career, but four years later Royal Mail was standing by me in quite a different capacity. Although bearing no resemblance physically to Red Rum, he was perfect in this new role as a model, being a very sensible horse. He would stand patiently for hours while I flexed a hock or a knee to check exactly what the ligaments and muscles did when the leg was raised.

Once the statue had been transported by lorry and installed in the converted barn my first task was to coat the plaster and scrim with shellac to seal it. Having applied two coats, I excitedly started sculpting. I had originally decided to model the life-size in clay, but I eventually changed my mind on the basis that since the first two models had been finished in plasticine it would be more consistent to continue in the same medium. Modelling went pretty well without a hitch until I came to tackling the legs. Although I appreciated the delicacy of a thoroughbred's legs, I still found I had not allowed enough leeway in the foam to enable me to create the indentations at the top of the limb and the tendons below the knee. This also applied to the surface of the hind legs, but particularly to just above the back of the hock. There was only one thing to be done: I would have to strip off the plasticine, cut away the plaster and scrim and remove some of the foam underneath. It was not a major operation, but it was obviously a set-back. Having carved and rasped the offending polystyrene away, I applied fresh plaster and scrim before trying again. This time there was no problem.

From the moment the strange embryo was unloaded from the lorry my four-year-old son, Dan, took an immediate interest in my work and one day he asked if he could help. Thinking he would become bored within a few minutes, I allocated him a virgin hind leg. For three days he laboured with single-mindedness and concentration, whilst every now and then I tried gently to suggest alternatives to "helping" me. However, nothing would dissuade him from continuing. He would stand back proudly and admire his handiwork as it gradually spread up the hind leg. With growing dismay I knew that somehow I would have to strip it down and rework it without his knowledge. Luckily the following day was the first day of term so, as the car disappeared down the drive, I hastily set about the task. By the time he returned from school at four o'clock I had completely remodelled

the leg to my satisfaction. On entering the studio, a look of consternation came over Dan's face as he examined the statue.

"What's happened to my leg?", he asked. With all the casualness I could muster I replied that I had just smoothed it out here and there where he had missed a bit. "But Daddy, you've ruined it!", he cried, and stomped off in high dudgeon.

After a month of working on the statue it had reached the stage where we needed the horse himself so I could work from life. Beryl McCain and her daughter, Joanne, kindly brought the horse down to Yeatmans Farm. The plan was to leave him with me for some time while they returned to Southport the following day. The horsebox would pick up Red Rum the next time it was in the area. Ginger had explained to me that Red Rum was now being led out rather than being ridden in the morning for exercise. He was suffering from a complaint similar to hardening of the arteries in his hind legs which caused him to become set-fast (a form of severe cramp) when he got excited. Having given me detailed instructions about his diet and exercise routine, Beryl and Joanne headed off early the next morning to spend some time riding out at John Francome's stable in Lambourn. They planned to return later in the day before heading back home. In the meantime I took Red Rum out for his morning exercise. As I pulled him out of the box he put in a series of huge bucks and kicks which made me wonder whether I would soon lose sight of him making tracks down the Witney by-pass. By the time we had reached the end of the drive he had, thank goodness, settled down, but we had hardly managed another two hundred yards before his boisterous behaviour of five minutes earlier was replaced by a sudden lethargy. Realising that he was starting to become set-fast, I tried to keep him on the move but, to my horror, he froze on the spot and immediately broke out into a sweat and started to heave alarmingly. Obviously his earlier antics had brought on this attack which quite clearly caused him considerable pain. Fortunately I managed to get him moving again and after a few minutes the spasm passed. Soon he was contentedly picking grass at the side of the road and generally behaving as if nothing had happened. However, the experience had unnerved me. In those few minutes every day of his twenty-two long, hard years had suddenly been written across every dilated vein and it was brought home to me that the exuberant and glossy individual that bucked and squealed round my yard not long before was also a vulnerable and a very old horse.

That day was one of total preoccupation as I worked on the statue with Red Rum. I realised I could not possibly have done the job satisfactorily without getting the two together. Several points were immediately obvious.

The model needed much more "bone", i.e. the legs needed strengthening, particularly at the knees and fetlocks. The hindquarters also required building up substantially. However, all these anatomical differences, once observed, could if necessary be attended to after the horse had gone home. My highest priority was the head. This could only be modelled from life. Later that afternoon, Beryl and Joanne arrived back and I told them about my unnerving experience during the morning. I then explained that if I could keep the horse for just a little longer, I would not need him again. They very kindly agreed to stay on for two more nights and to take him home when they left. I figured that if I worked every daylight hour for the next two days it would be sufficient for me. What I actually needed was someone to make observations and to work on the body while I concentrated on the head. One telephone call was all it took for Margot to drop everything and drive up from Hampshire. She arrived at eight o'clock the next morning and we set to work. After forty-eight hours I felt happy to let Red Rum go home. Before he went we turned him out in my paddock for a while to allow him time to relax. Out in the field he looked so at home and such a picture of contentment that I decided to take some photographs. The resulting prints included several of him and Shovel the cat, which later inspired me to model a piece entitled, "Red Rum at Yeatmans Farm". In this I aimed to capture the Red Rum personality of today, a different angle to the statue which portrays him at the height of his powers. Generally speaking, I shy away from anything approaching sentimentality, but on this occasion I felt justified in commemorating the horse's visit. The sculpture is now complete and, although I say it myself, I do believe I have caught a really good likeness of him, not to mention the cat!

After Red Rum's departure, I still had a lot of work to do, but I felt I now had all the information I needed to complete the sculpture. By this time I was enjoying myself immensely and every morning I would look forward with eagerness to the day's work. What a wonderful way to make a living, I thought, with elation. Although working on this large scale presented problems not encountered on miniature forms, there were times when it made the job easier. Curiously I find the sense of touch is sometimes a more reliable guide to memory than sight. Very often, if I were having a problem getting, for instance, a knee right, I would run my hand down the leg and compare how it felt rather than looked. I tried this tactile approach all over the statue and it was particularly helpful on delicate and finely moulded areas such as the head and, as I've already said, the legs. Although it is possible to apply the technique to a smaller model, it is really only authentic when dealing with a life-size model: by closing the eyes a mental

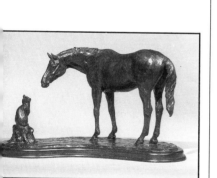

'Red Rum at
Yeatmans Farm'

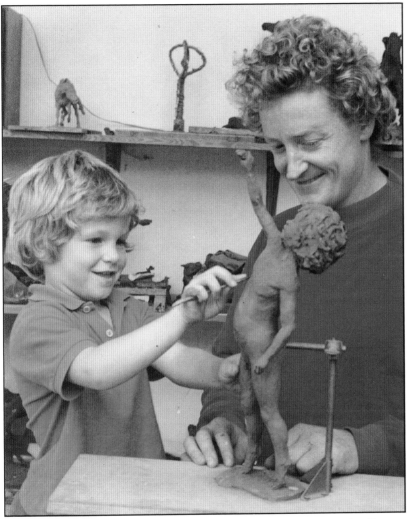

My son Dan makes some much needed improvements to my model of him, executed some eighteen months before, and subsequently shelved as not being up to standard.

picture is conjured up through the contours forming under the fingers.

Some weeks after Red Rum's visit, Ivan Straker accepted my invitation to see for himself how the project was coming along. He and his personal assistant, Liz Stevens, arrived for lunch by helicopter. A good patron is one who takes an interest whilst at the same time trusting the artist enough to allow him his freedom. Ivan put absolutely no restrictions on me over concept or positioning and this gave me the opportunity to create a truly uncompromised work, which is more than any artist can hope for. I was pleased with the progress I was making on the statue and was confident that Ivan would like it. All the same, I did feel a twinge of apprehension

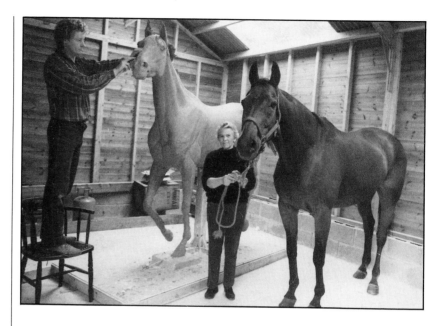

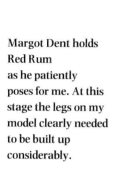

Margot Dent holds
Red Rum
as he patiently
poses for me. At this
stage the legs on my
model clearly needed
to be built up
considerably.

when I threw open the doors of my barn to reveal all. Ivan's reaction gave
me a warm glow of satisfaction. There was no doubt he was pleased, and I
knew that if he were happy at this stage he would be delighted with it on
completion. As his helicopter took off from the paddock, it was reassuring
to think that I could now complete the statue with his unconditional seal
of approval.

As autumn set in, my main concern was to complete the statue and to
send it off to the foundry before the weather turned really cold. My barn
was a good workshop during the summer months, but it was inadequately
insulated for very cold weather. This was not only for my own comfort
but, more importantly, for the benefit of the statue. If allowed to become
exceptionally cold, the plasticine would contract and crack, apart from
being impossible to work. Luckily the weather was still fairly mild, but
even so I had to have two gas heaters going during the day. One morning
I inspected the statue and found some small cracks forming on the outer
skin. I decided that the extremes in temperature between the cold nights
and the days with the heaters going full blast were having a detrimental
effect. From then on I kept both heaters on for twenty-four hours a day.
This certainly made my local ironmonger happy, because I was going back
and forth every two days to replace the cylinders. As the weather grew
colder, the cracks increased and so did my worry. Every day I would model
one out, only to find it had reappeared the next day. I resolved to finish the

model before Christmas, so that I could get it away to the foundry before the holiday break.

By the middle of November the sculpture was nearing completion except for the finishing off process. This involved smoothing off the plasticine to produce a perfectly crisp and simple surface. This turned out to be an enormously time-consuming business. It did not require much skill, but a great deal of patience and dedication. On one occasion, after working all morning on an area about nine inches square, I decided to try to get some help. Once again, Margot stepped into the breach and several times travelled up to undertake a laborious day's smoothing. After that, the only item left to tackle was the base, which I had made separately so that it could be fixed on after the casting.

At last the day came when I decided I could do no more. In the cramped space of the barn I longed to be able to stand right back from the statue, but the best I could do was to open the double doors and peer in from the yard at the head of Red Rum gazing intelligently back out at me. All those months I had pictured in my mind how the statue should look and, thankfully, now my dream had become a reality. Keeping the studio constantly warm had arrested any deterioration in the cracks and so as long as we transported the model to the foundry before the weather turned bitterly cold we would be all right. A few days before Christmas I rang Morris Singer to ask if they could come out to pick it up. To my dismay they told me that they could not possibly reach me before Christmas, so I would have to keep heating the barn and hoping the weather stayed mild until 6 January. Throughout Christmas the family festivities were nearly ruined by my constant reference to the current state of the statue. After a particularly long and boring analysis of one rather stubborn crack that kept re-appearing, I was told by my wife during Christmas lunch to stop belly-aching and to eat my turkey!

The next operation in the making of the statue was to cut it up into sections for casting. After much discussion with the foundry, we decided it would be safer if we kept it intact for transportation, with the exception of the tail, which we would saw off before the journey. On 6 January an open truck arrived with Arthur, the foreman, and two other men from the foundry. I was rather perturbed to see that my statue would have to travel exposed to the elements, with overhead branches being a real danger, but I just had to hope for the best. Having sawn off the tail we manoeuvred the statue gently out of the barn doors. In an adjacent field, Royal Mail and Bambi, his Shetland pony companion, looked on in astonishment as this grey, immobile horse was man-handled into the truck. Eventually when

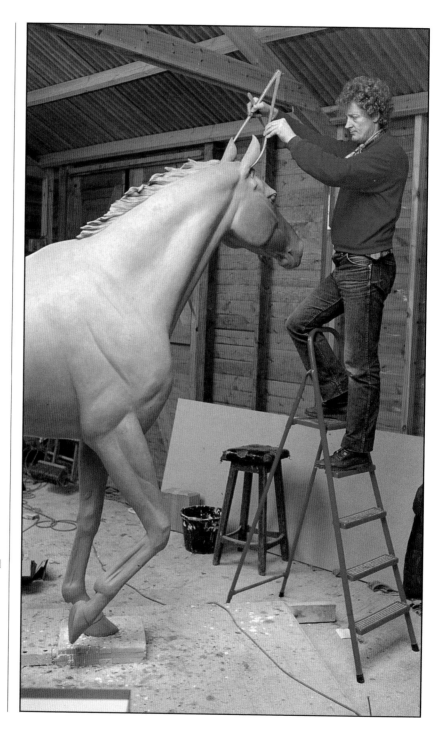

The statue nears completion. Once I had started modelling I found that in order to achieve the fine detail of the ligaments and tendons more foam had to be removed from the legs. I don't look as though I would do 10st 7lbs in this photo!

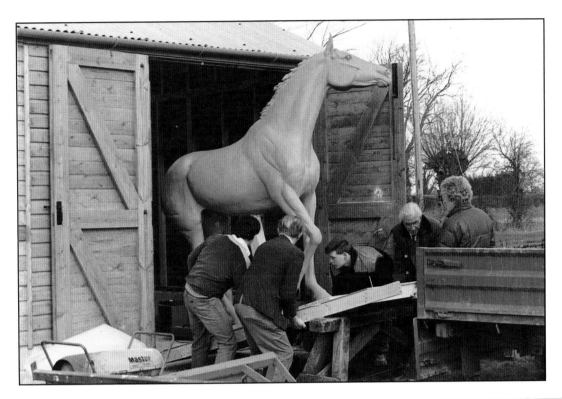

the model was safely tied on, the three men set off for the foundry. It was a curious sight seeing my statue trundling off down the drive, with the willow branches barely skimming the horse's ears. I was so concerned about the danger to it during the journey that I asked Arthur to telephone me as soon as they arrived to put my mind at rest. However, all was well and that evening I walked into the empty barn. Suddenly the presence that had not only filled the barn but my life, too, for the last few months had gone, leaving me with a feeling of emptiness and anti-climax. During all that time the barn and the creation developing within its wooden walls had been the epicentre of activity at Yeatmans Farm. Where I was standing the statue had been discussed, refined, worked on, cut away, modelled and discussed again until I felt it had reached as near as possible my idea of perfection. Rather wistfully I removed all the evidence of our efforts – the photos and sketches pinned to the walls, a couple of bags of plaster, a ladder, some tools and all the paraphernalia of a sculptor's workshop – leaving the barn not as a studio for housing a life-sized statue but, once again, as a modest woodshed. That night the temperature plummeted to several degrees below zero and stayed there for the next three weeks. We had only just made it.

Ron Bailey from the foundry saws off the tail with a powered hack-saw before the statue is manhandled onto the back of a truck under my anxious gaze.

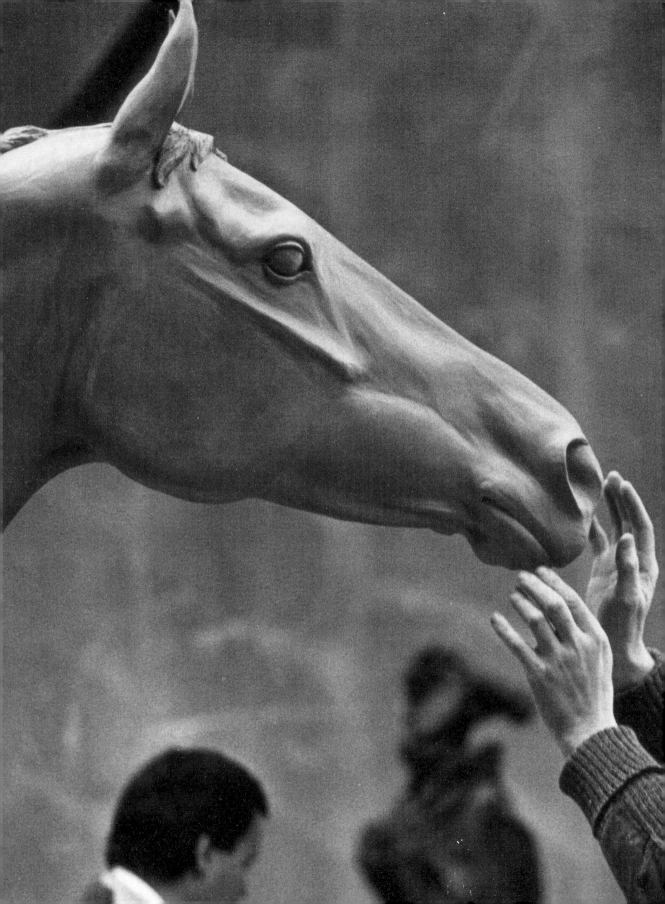

Believe it or not this pose was not for the benefit of the camera, but merely a last minute check of the head before de-capitation.

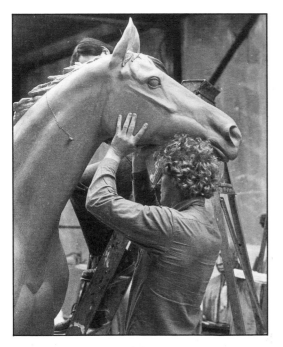

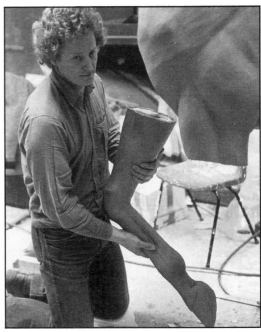

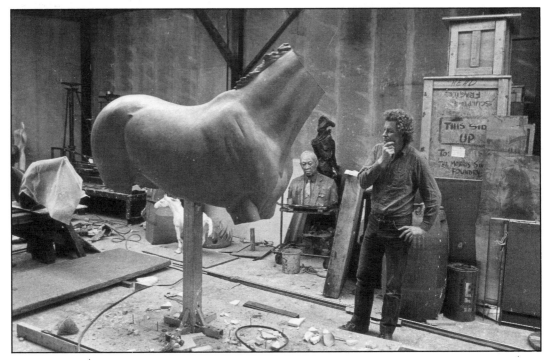

Chapter Ten

THE FOUNDRY

FOR THE CONVERSION of my sculpture into bronze, the foundry had decided to use two methods of casting. The torso was to be cast by the sand-casting process, whilst the more delicately modelled areas, such as the legs, the tail, the mane and the head, would be cast using the *cire perdue* or lost-wax method. However, first of all we had to go through the agonising process of cutting it up into sections. I drove down to Morris Singer to supervise the procedure. Taking care not to cut directly into a joint, we removed the head using a powered hack-saw; then came the legs and the mane, as the tail had already been removed. This process took several hours, because sawing through the thick aluminium armature was time-consuming. Now the whole performance was out of my hands.

To prepare the torso for sand-casting it first had to be cast in plaster. It was placed on its side and a latex rubber mould was made in two halves around it. This was done by pouring a liquid rubber solution around the model which contained a catalyst to ensure quick hardening. A plaster positive, which was a direct replica of the original, was then taken from the mould and from this a sand-mould was created. Making a sand piece mould requires consummate skill and technique that are not easy to find these days. Basically the mould is made by creating a negative impression of the original in hardened sand. The moulder lays the plaster model on its side and finds a line approximately mid-way down the work. Where undercuts occur he makes tapered piece moulds in sand to enable the mould to be removed undamaged from the original. On reassembly, the pieces slot together like a jigsaw to form a complete mould. Next, the frame containing the sand and model are turned over, care being taken not to disturb the compacted sand, to expose the underside. Chalk is then sprinkled over the sand surrounding the upturned model to prevent adhesion when the other half of the sand-mould is applied. The whole process is repeated, but this time tubes through the sand are formed through which the bronze can be poured. The top half of the main mould is lifted away from the underside exposing the top of the plaster model, which can then be removed from the bottom half.

In the case of a small-scale model the mould would now be ready to cast into solid bronze. However, to cast "in the solid" on a large-scale would

Top, left: Grimly holding on, hoping I don't drop the head as it is sawn off.

Top Right: A leg gets the same treatment.

Bottom: The cutting up process is complete, but I can't help feeling apprehensive and hoping that the foundry know what they are doing.

not only be a waste of expensive bronze, it would make it enormously heavy, and, more importantly, there would be a risk of cracking and distortion during the cooling period. In order to cast bronze hollow, a core has to be built to create a cavity down which the molten bronze can run. To make the core, the moulder takes a positive replica of the original in sand which is strengthened by an armature. He then pares off approximately seven millimetres from the surface, creating a channel between positive and negative for the bronze to form a skin. As can be imagined, great skill is required to carve away a uniform amount to ensure a constant thickness of bronze. The complete mould is then assembled, with the core inside being supported by a series of gates and vents. Molten bronze at a temperature of 1250°C is then poured in from the top, down through the channels, filling the cavity created by the outside negative and the slightly smaller inside positive. The bronze is then allowed to cool for at least twenty-four hours before it can be removed from the mould. Finally, the runners have to be taken off and the raw metal has to be chased and cleaned. This sounds and is, as I have said, a highly complicated and skilled procedure and the sculptor has to rely totally on the craftsman to duplicate his work as faithfully as possible. Luckily in the case of Red Rum, the foundry did a wonderful job.

Now it was the turn of the head, the mane, the legs and the tail. It may seem curious to adopt two methods of casting for one sculpture, but because of the difference in size and detail of the torso this seemed the best solution. To apply the lost-wax method to the bulk of the sculpture would have meant making a huge and unmanageable mould that would have been entirely impractical and unnecessary. However, the more detailed areas required more refined reproduction. In four thousand years or more since the *cire perdue* method was first employed, a more faithful way of casting delicate work has not been found. Recent developments, such as the introduction of a cold-setting synthetic rubber for mould making, have also facilitated the process. Firstly, the moulder makes a negative impression with the use of the cold-setting rubber. Because of the flexibility of this material when set, the mould can be made in just two halves, even with numerous undercuts which a few years ago would have necessitated the making of a piece-mould in plaster. The two rubber halves are held rigidly in place by a thick outer plaster shell which prevents any movement when the wax is applied. After coating the rubber with a liquid to prevent adhesion, the molten wax is painted on to the master mould in layers until a thin coating has formed. The two halves are joined together and more molten wax is poured into the already coated interior. The wax is swilled

Here the torso is moulded from latex rubber. A plaster positive is then taken before the sand casting process goes ahead.

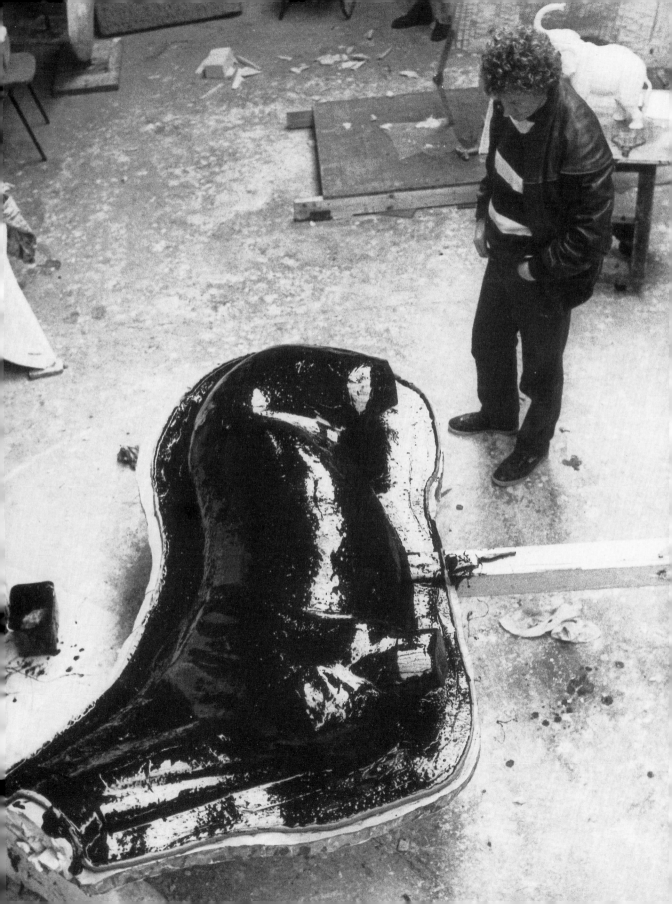

around the mould until sufficient has hardened on the negative and the excess is poured away. A shell inside the mould has now formed which will eventually be replaced by the same thickness in bronze. The hollow interior of the wax shell is then filled with a "core" made from water mixed with plaster and grog (reground fine clay). Once the core has been allowed to harden, the mould is carefully opened to expose the wax replica of the original. All along the seam, or where the two halves of the mould have been joined, it is necessary to retouch the wax. At this point, the sculptor usually checks the work and retouches with a heated tool any imperfections that may have occurred in the casting.

The next stage is to hammer into the wax casting. Small brass nails and pins are driven through the wax at various points to penetrate the inner core. Their purpose is to support the core after the outer investment (casting) has been added and the wax has been burned away, leaving an empty space into which the bronze can be poured. Without them, the core would simply drop to the bottom of the mould without the wax to support it. A network of runners, gates and air vents has to be attached to the wax to allow the metal to reach every extremity. These take the form of solid wax tubes of varying thickness which connect up to each other and which will eventually feed the bronze to all parts of the mould from a funnel at the top. Similar wax tubes in the form of vents extend from all points to prevent air being trapped inside the negative cavity. The outer investment is added, first with a very thin "slip" composed of water and dental clay and then built up with a rougher fire clay to create a rigid retaining wall containing the whole. The mould is then placed in an oven, where the wax is burned away or "lost".

Bronze is made up of approximately 75 per cent copper and 25 per cent tin. However, it can also contain lead, nickel, zinc or silver in small proportions. This alloy is melted down in a furnace sunk in the floor of the foundry. Once it has reached the required temperature it is poured into the funnel at the top of the mould until the latter is full. The bronze is then left to cool for at least twenty-four hours before the mould is cracked open. Once the bronze has been cleaned of its outer investment the runners, vents and nails have to be removed. A hole is created in an unobtrusive place on the bronze through which a core is extracted. Failure to rake out the core properly can result in the patina eventually becoming badly discoloured. Now the time-consuming business of chasing and riffling begins. This is the highly skilled process of filing and chiselling to bring the bronze up to the standard of finish of the original. Inevitably, there will be small faults to be corrected and lines to be clarified. Where the runners

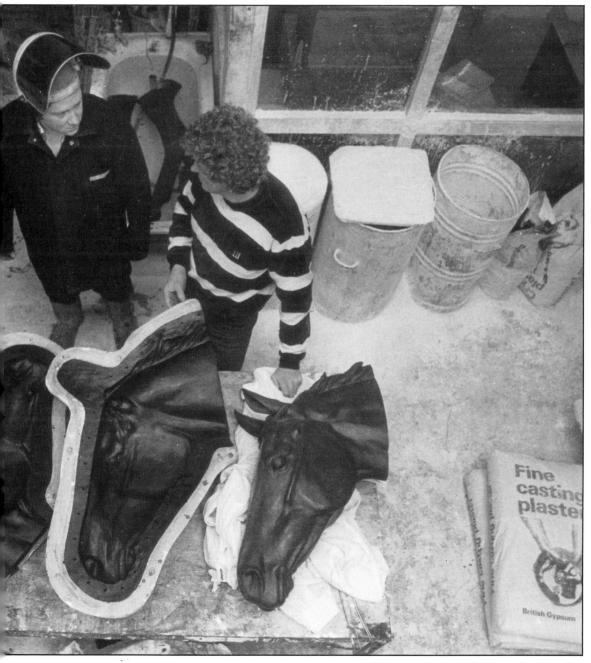

The head is now in wax and has been removed from the two negative halves to its left.
The rubber mould is held in place by the thick plaster shell surrounding it.

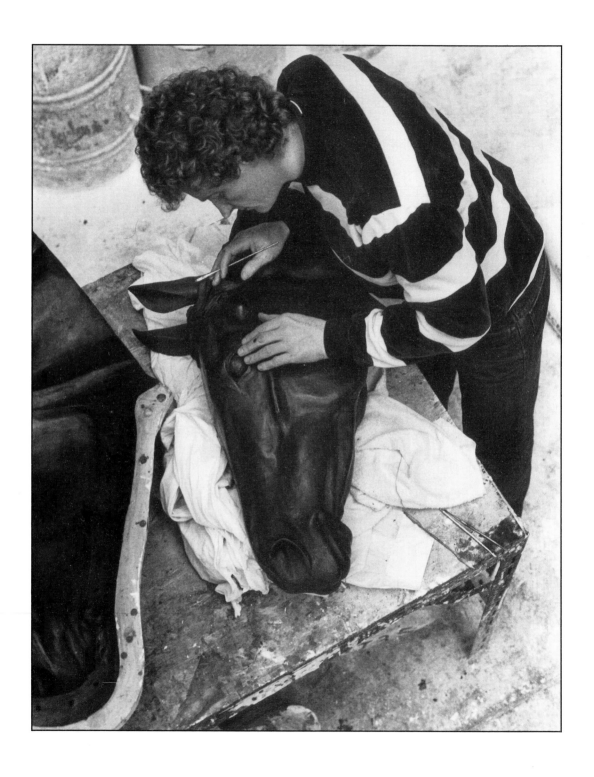

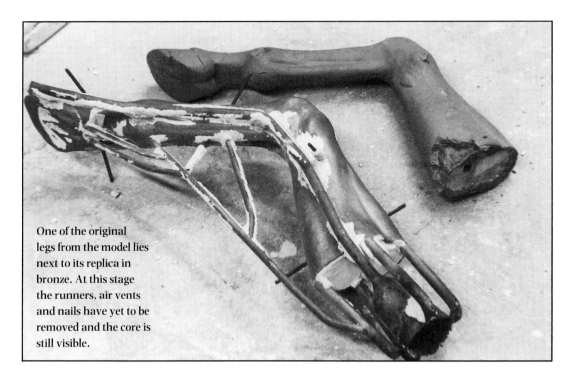

One of the original legs from the model lies next to its replica in bronze. At this stage the runners, air vents and nails have yet to be removed and the core is still visible.

Opposite: By using a heated tool I am able to touch up the wax and correct any imperfections that may have occurred in the casting.

Above: The head is being 'chased'.

(now in solid bronze) have been connected to the piece, the surface of the bronze has to be reworked to match the texture of the original.

Under normal circumstances the bronze would now be ready for patination, but in the case of the Red Rum statue all the various sections had to be joined up before this could take place. The process of casting inevitably means that there will be a small amount of shrinkage when the bronze cools, which produces a finished piece that is very slightly smaller than the original model. The amount of shrinkage from a sand-cast is slightly less than one from a lost-wax cast. For this reason, I was concerned when it came to joining up all the sections that they should marry up convincingly. I should have had more faith in the skill of the foundrymen. Where there was a slight discrepancy, some fine adjustments were made to both sections to ensure a perfect fit. Before the legs were welded on, steel plates were fitted on the inside at the join to reinforce them. To strengthen the tail, a steel rod was inserted down the centre join and welded to the inside of the quarters. Finally, and most importantly, the two legs which had to take the full weight of the statue had to be reinforced with steel rods which ran down the legs, through the hooves, through the bronze base and out to approximately one foot beyond. The twelve

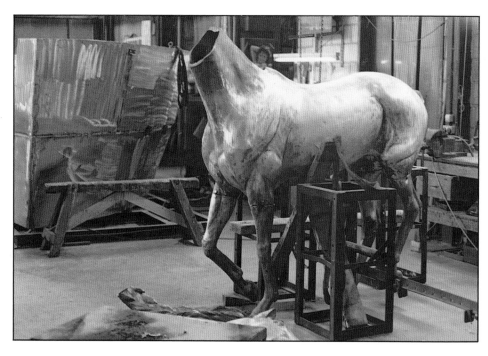

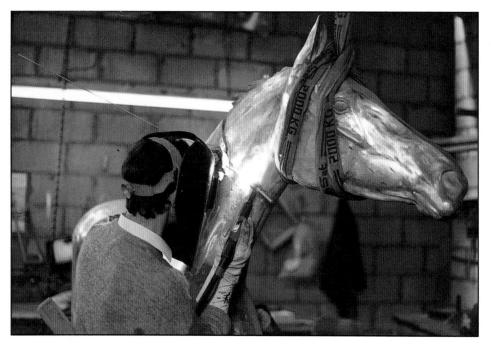

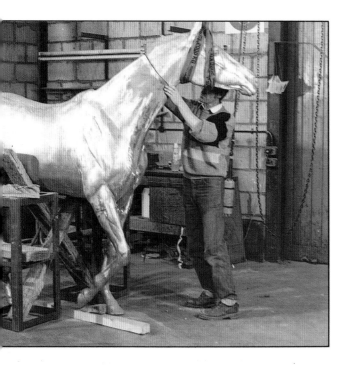

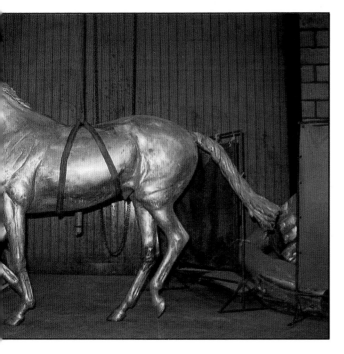

With the chasing completed, the various sections have now to be welded together.
Top, left: The legs are fitted into place ready for welding. Steel plates have been used on the insides to reinforce them at the join.
Top, right: The head is lowered into position.
Bottom, left: The head is welded on to the neck.
Bottom, right: The sections having been successfully joined up and chased, the statue is then fixed in the correct position on the base.

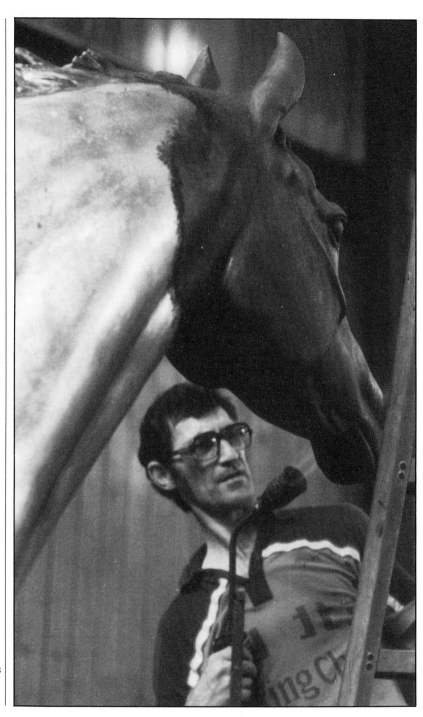

Reg Woolf makes a start on the colouring process. Here he applies the first coat of ferric acid.

inches of exposed steel would then be sunk into the concrete plinth on site.

Now we had to fit the statue to the base. For convenience I had modelled the base separately, so I had yet to see the two juxtaposed. This was very interesting for me, because I had designed the statue to be set diagonally across the base to give the impression of the horse side-stepping and I had purposefully avoided the conventional position of the horse standing square with the base and plinth. The base, therefore, assumed an importance beyond its usual humble role: it was not until the statue was seen properly positioned on it that the observer became aware that the horse was moving off a straight course, at which point the full intention of the design was revealed. I was astonished, when the statue was lowered precisely onto the markings I had made on the bronze base, how suddenly it assumed a new dramatic dimension. Instantly it was there – my original design of a year before – but as large as life.

The final process of colouring a bronze is so crucial that it can make or break a work. No matter how excellent the modelling and the casting, an unsatisfactory patina can make even the most original and exciting work seem flat and uninteresting. Colouring is achieved by the application of a mixture of chemicals to the surface. The bronze is heated by a blow-torch while the solution is simultaneously stippled on with a paintbrush. The colour can range from black through all the various hues of brown. Shades of blue and green can also be achieved. It is a very inexact science and the result can never be absolutely predicted, no matter how skilfully applied.

I spent several days at the foundry with Reg, who is an expert at colouring, experimenting with various mixes of chemicals. Not only is it important to choose the right chemicals and apply them correctly, but also the amount of heat that is administered at the same time is crucial. All these factors combine to determine the hue and richness of the patina. We decided after several trials on small areas of the base to plump for an under-coating of ferric acid, applied hot, which produced a rusty red appearance. This would give the statue a richness that would show through the highlights when the two coats of "liver" (a chemical colour) were administered. Finally, we coated the bronze with beeswax, polished it up and stood back to savour the result. It positively glowed under the foundry lights. Reg had done a superb job with the patinating and his patience in searching for exactly the right tone had undoubtedly paid off.

Chapter Eleven

THE UNVEILING

AT THE TIME of writing, the statue is still stored at Morris Singer, awaiting erection at Aintree. Just a couple of weeks before the Grand National meeting it will travel to its final destination in time to be unveiled before the big race. The following week will see the opening of my one-man exhibition at the Tryon Gallery in Cork Street, London. In the show I will be exhibiting the one-third life-size maquette, which contributed so much towards the making of the statue, and some more recent work. A few non-racing subjects will be on display, in particular the fruits of a visit I made to Appleby Fair in June 1987. Although racing and horses remain the source of my main inspiration, I am very aware that I must move on, otherwise I will stagnate. Movement is still very important to my work but I am turning my attention to other sporting figures and finding new and exciting material.

This will, in fact, be my second major exhibition, my first having been held in November 1983. When I eventually retired from the saddle at the end of 1982, I knew I had to have a launching-pad for my new career. I had been selling my work through the Tryon for the last few years and since I had developed a good relationship with them and they were (and are) the top sporting gallery in London, I was delighted when they agreed to stage a show for me. I gave myself eighteen months to prepare for it and worked hard in that time, as I knew that the exhibition would either make or break me. In the fortnight of its duration I would discover the brutal truth about my ability. Sue and I had spent weeks planning the show, arranging publicity, erecting posters, sending out photographs, making lists of names and addresses for invitations and trying to ensure that nothing was left to chance. It produced a sense of anticipation not unlike that experienced during the build-up to a big race. Anything short of a success would cast doubts upon my prospects as a sculptor. There was also the added pressure of having put a considerable amount of money into the exhibition which I hoped to recoup. In particular, I had had to borrow a hefty sum from the bank to pay for my casting costs.

On the opening night I apprehensively watched as the gallery started to fill up, eventually to become a heaving mass of people. After about an hour I realised that the gallery was doing a roaring trade and by the end of the

opening night we had well exceeded my ambitions for the whole exhibition. There was more to come, and the next two weeks were unbelievably exciting. I never imagined when I gave up racing that I would ever again experience the buzz I felt when riding a winner. This was as stimulating but more satisfying. Quite apart from the actual sales, which continued unabated throughout, I was especially honoured by and grateful to all the hundreds of people, not necessarily buyers, who took the trouble to come and see my work and show real interest in it. Catalogues ran out after a few days and more had to be hurriedly printed. John Edwards and Stan Mellor, the two trainers for whom I had ridden most, did not forget me either. They and many of their owners for whom I had also ridden over the years supported me to the full on my opening night. Their encouragement and help, for which I shall always be indebted, provided the fillip that my career needed at the time.

From that moment on I have been busy and that's all that one can ask from a job one loves. Ivan Straker's commissions of the Seagram Grand National trophy and the statue have brought me new and inspiring challenges which I hope I have met successfully. The trophy was presented by Seagram in the Sefton Suite for the first time in 1986 to the owner of the winner, West Tip. I congratulated the jockey, Richard Dunwoody, who had given the horse a brilliant ride and his owner, Peter Luff. Then, with an effort I hope I concealed, I shook the hand of the winning trainer, Michael Oliver, and offered him my felicitations. Ironically, Michael was the only person with whom I had seriously fallen out during my riding career, but I could not let old differences spoil the occasion.

Ivan Straker kindly invited me to the National again in 1987 and I felt a sense of anticipation and personal involvement in the finish. Three horses jumped the last more or less upsides and had a tremendous battle on the long run-in. I felt a loyalty to those connected with all of them and as each, in turn, took up the running, I wanted all three to win. In front till the elbow was the Tullochs' horse, Lean Ar Aghaidh, trained by Stan. He was overtaken by The Tsarevich, owned jointly by Edgar Bronfman and Ivan Straker, and trained by a long-time friend, Nicky Henderson. For a brief moment it looked as though Ivan, one of the saviours of the Grand National, was about to fulfil a dream. Finally, Jim Joel's black and red colours hit the front as Maori Venture stormed up the run-in to give my great friend, Andy Turnell, the training victory he needed to publicise his undoubted, but unadvertised, talents. Minutes before the race we had been sharing a bottle of champagne with Andy and his wife, Louise, jokingly predicting the result as a Turnell one-two. (His other runner, Tracey's

Special, finished the course but was unplaced.) Andy seriously thought Maori Venture had a good chance if he jumped round, which many of the pundits considered highly unlikely. As I felt confident in the horse's class, I had a good bet with the Tote. To my horror, when I presented my ticket at the pay-out desk, I found the girl had mistakenly given me one for West Tip. In future I shall always check my Tote tickets, as it cost me several hundred pounds that day. Of course, this did nothing to dispel my delight for Andy. On the death of his father, Bob, Andy had immediately hung up his boots and taken over the yard, but it was far from stepping into the ready-made position it might have appeared. After having to find new premises, Andy and Louise had struggled to become established. Despite some considerable success and a clear talent, owners and horses were in short supply. They deserved to win the National and if there is any justice they will have a yard brimming with horses from now on and many more worthy winners.

To all the world, 9 April 1988 is Grand National Day, but to me it will also be the end of a wonderful phase in my life. The unveiling of the statue will be the culmination of two years' work. I could not have achieved it without Alma, whose help with the armature, foam and scaling up was inestimable, the team at Morris Singer, who worked tirelessly to convert my fragile model into durable bronze, Margot, who drove up from Hampshire to help and advise, and my wife, Sue, who could be relied on to be brutally frank in her valued opinion about my work. The making of Red Rum was undoubtedly a team effort.

As for the future of the Grand National, prospects have never looked brighter. The last few years have brought record crowds and in the very commissioning of this work Ivan has demonstrated complete confidence in the continuance of the race for the foreseeable future.

By the time these words are in print, Red Rum in bronze will be in place, gazing out towards the course he made his own. I hope it will symbolise the great revival of the Grand National and the secure future of the course. It will always serve as a reminder of the debt owed by Aintree, and all those who love the National, to Seagram and, in particular, to Ivan Straker. With luck, Red Rum is still enjoying full retirement, looking out from his regular box at the top of the McCaines' Southport yard. Without their generous co-operation in allowing me such unlimited access, the result would not have been the same.

Red Rum's unique story and his own vibrant character have captured the imagination of millions: he never received the chance to mature in a paddock for the first few years of his life, as most chasers do; he rose above

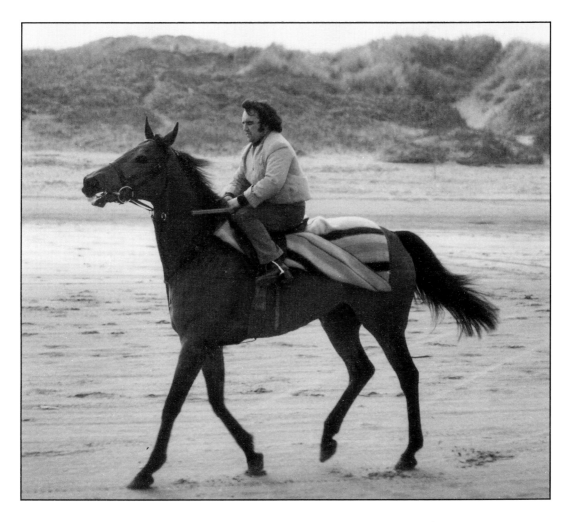

his unhopeful start as a two-year-old selling plater to achieve immortality from an unconventional yard. Here he was not surrounded by the rolling Berkshire Downs of Lambourn or the Yorkshire Moors, but by the suburban streets of Southport and the sands which proved so beneficial to his troublesome feet. Perhaps it is because he, in some way, symbolises the triumph of the underdog when all the odds are stacked against him that he became by far the most loved and celebrated horse in the nation's history. His indomitable spirit, which enabled him to shrug off the trials and perils of the most testing steeplechase in the world, has been the key to the whole concept of the statue. If I have managed to capture something of this, then perhaps I have succeeded in my task.

The inspiration for the statue – Red Rum on the sands.

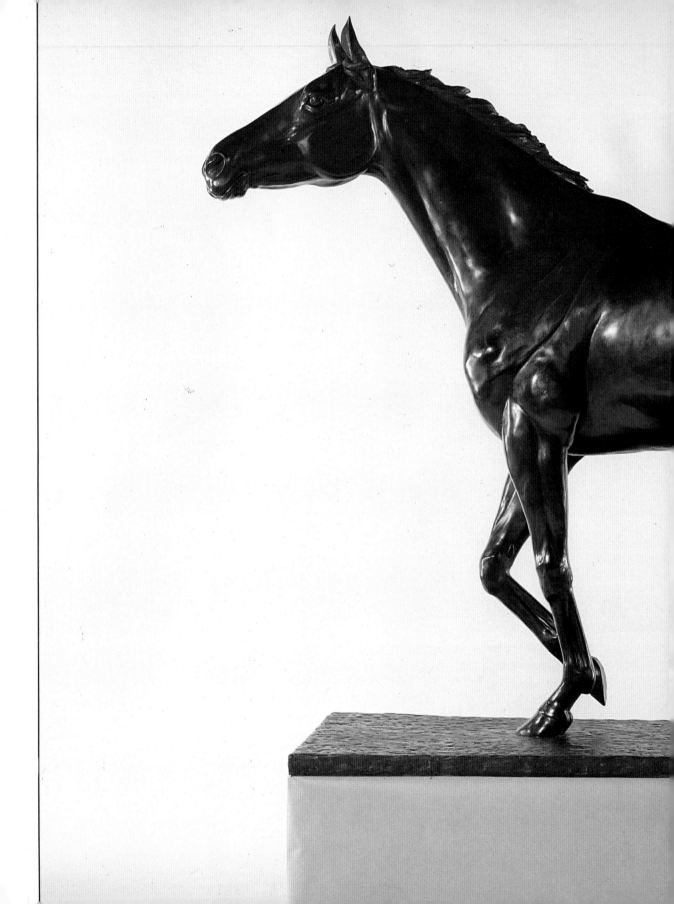

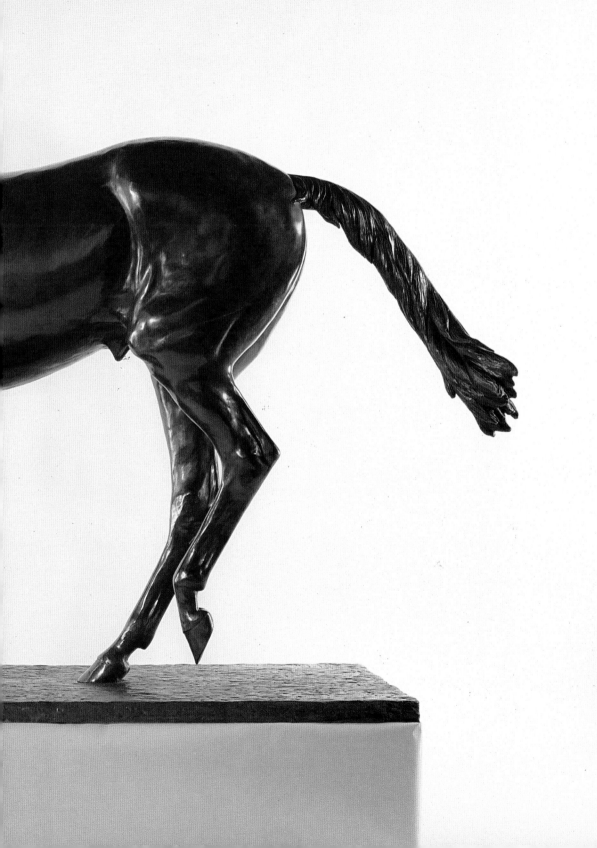

All pictures in this book are
by GERRY CRANHAM except the following:
NIC BARLOW: page 11
PAUL CRANHAM: Title page; page 114
KEYSTONE (PHOTO SOURCE): pages 17; 33
PACEMAKER INTERNATIONAL: 54
PHILIP & SUE BLACKER: pages 72; 77; 78;
79; 80; 95; 105; 106; 108
BERNARD PARKIN: pages 53; 56; 57
ALL-SPORT: page 63
SPORT & GENERAL: page 84
OXFORD COUNTY NEWSPAPERS: page 91
WILTSHIRE NEWSPAPERS: page 92

LA COUPE DE GYPTIS

CLAUDE COTTI
PRESIDENT DE LA SOCIETE ACADEMIQUE
DES ARTS LIBERAUX DE PARIS

LA COUPE
DE GYPTIS

POEMES

**SOCIETE ACADEMIQUE DES ARTS LIBERAUX
DE PARIS**
MCMLXXVI

AVERTISSEMENTS

1° PROPRIETE - L'Association garantit par ses Statuts à tous ses membres la libre disposition des œuvres qu'elle publie. Ceux-ci déclarent accepter les conditions de l'Association, lui donner leur autorisation de reproduction dans sa collection et la garantir contre tout recours de ce fait, même en cas d'appel en garantie et de pluralité de demandeurs, si les auteurs se sont dessaisis des droits sur les œuvres publiées ici, que l'Association ne saurait revendiquer. Seuls les membres de l'Association peuvent être publiés par elle.

2° COMPETENCE - Les personnes dont le nom, après avoir figuré sur les listes publiées dans les précédentes publications, ne figure plus dans le présent volume, ne peuvent ignorer qu'elles ont, par leur silence, abandonné l'Association. Tout usage de leur nom les présentant comme membres actuels de l'Association n'est pas conforme à la définition de la délicatesse pratiquée par les membres et, en cas de refus de rectification et de cessation de cet usage, expose à tout recours de droit, aucune dérogation antérieure de fait ne pouvant faire novation.

3° USAGE - L'Association n'accorde son patronage à aucun envoi systématique à ses membres de bulletins de souscription, d'abonnement, de participation, d'admission et autres demandes d'argent au profit ou en faveur de tiers, même membres de l'Association. Les demandes de l'Association doivent émaner du Président, et avoir pour seul but de faire connaître l'œuvre ou d'honorer la personne des membres. Conformément aux Statuts, le Président ne peut déléguer ses pouvoirs qu'à la Secrétaire Générale et au Trésorier Général.

4° RECRUTEMENT - Toute personne qui se croit un talent d'écrivain ou d'artiste peut adresser une demande au Président, qui examinera l'œuvre ainsi soumise avec compréhension et discrétion. *Quoique sans obligation de périodicité, l'appartenance à l'Association est réservée à ceux qui ont publié dans sa Collection ou qui ont des intentions précises de le faire.*

————

Tous droits de traduction, d'adaptation et de reproduction réservés pour tous pays.

© *CLAUDE COTTI, 1976*

ISBN 2-85305-052-1

SOCIETE ACADEMIQUE DES ARTS LIBERAUX DE PARIS

Association culturelle sans but lucratif
Déclarée à la Préfecture de Police de Paris sous le n° 62/1160

Editeur ISBN 85305

« Le Panoramique », 3, avenue Chanzy
94210 La Varenne-Saint-Hilaire
(Commune de Saint-Maur-des-Fossés, Val-de-Marne, France)
Téléphone : Paris (1) 283-36-03

PROMOTEUR :
 Claude COTTI, Président

ADMINISTRATEUR :
 Alice COTTI, Secrétaire Générale

CONSEILLER ARTISTIQUE :
 Comtesse Rosa-Maria DONATO DI TRISCELON
 Déléguée à Rome

CONSEILLER LITTERAIRE :
 Maître Lilia-Aparecida PEREIRA DA SILVA
 Déléguée à Sao Paulo

ASSESSEUR :
 Michelle-Josépha TARSON, Vice-Présidente

Ouvrages préfacés par CLAUDE COTTI

ALICE COTTI

Sans perdre mon Latin, Illustrations de Claude Cotti.
ISBN 2-85305-021-1
Nouvelles du Pays, Illustrations de Claude Cotti.
ISBN 2-85305-022-X
Poing à la Ligne, Illustrations de Claude Cotti.
ISBN 2-85305-023-8

LILIA-A. PEREIRA DA SILVA

Fleurs de Lilia, Illustrations et Adaptation de Claude Cotti.
ISBN 2-85305-025-4

ROSA-MARIA DONATO

Palette Calabraise, Illustrations de l'auteur.
ISBN 2-85305-026-2

ANTHOLOGIE DES SOCIETAIRES
Avec tous les Membres du Comité Central
ISBN 2-85305-024-6
FR ISSN 0081-072X

**PREFACE
DE L'AUTEUR**

PREFACE

Une nouvelle fois, je présente au lecteur une œuvre en vers classiques, « La Coupe de Gyptis ». Je l'ai composée en évoquant la gracieuse légende de la fondation de Marseille. On sait que des Grecs venus de Phocée, en Asie Mineure, sous le commandement d'Euxène, s'arrêtèrent, vers 600 avant notre ère, près de cet endroit désert de la côte, dans l'espoir d'y fonder un comptoir. La délégation, conduite par Protis, fut reçue avec amabilité par la tribu Ligure de l'intérieur la plus proche, et le dynaste Nann invita le jeune chef à assister au banquet de mariage de sa fille, Gyptis. Au cours de celui-ci, elle devait, selon la coutume, choisir elle-même son mari et tendre une coupe à celui qu'elle aurait ainsi, soudain désigné. A la surprise des prétendants, elle tendit la coupe au beau Protis, et reçut pour dot la colline où se dresse aujourd'hui la basilique de Notre-Dame de la Garde. Bientôt, une petite ville grecque se bâtit le long de la calanque du Vieux Port ; ce fut l'origine d'une grande ville, qui eut la fortune que l'on sait. Cette légende de fondation, moins austère que celle de Rome, m'a tenté parce que c'est l'une des plus gracieuses qui soit : elle a pour symbole l'amour et non la guerre.

J'ai voulu y voir toute la symbolique du voyageur qui part à la découverte du monde, plein de joie de vivre et d'ardeur, et qui y rencontre, non l'or terni du vieil eldorado, mais cet or plus précieux que tous, l'amour, avivé au contact humain de l'amitié, de la paix et de la compréhension entre les hommes et les peuples : fi de Don Juan comme de Lovelace! Protis est bien plus beau! Apollon triomphe de Bacchus, le dieu de l'esprit sur celui de la chair, l'âme sur la chère, comme l'aurait voulu, en réalité, Epicure, et cet amour-là annonce déjà l'amour courtois, cher au pays d'Oc, en ce geste gracieux de la jeune fille pour l'hôte étranger, le don de cette coupe, dont le vin doré est ainsi le véritable or du monde, coupe qui est comme une préfiguration du Graal, de même que la leçon de l'agonie de Socrate annonce celle du Christ, en cet Orient méditerranéen qui, en fondant Marseille, fondait peut-être l'Occident, notre civilisation, issue de la Grèce.

De ce point de départ, j'ai mis à la voile, sinon à la plume, en pensant à Pythéas de Marseille, le grand navigateur antique, découvreur de Thulé, ce royaume du Nord dont le roi, dit-on, jeta à la mer la coupe du souvenir de son aimée, et ne voulut ensuite plus jamais boire! La légende de Gyptis est beaucoup moins triste, c'est une légende claire et lumineuse, assez rare, si on la compare à toute une littérature héroïque, de la guerre de Troie à la guerre de Cent ans, comme par exemple la légende celtique de Tristan et Yseult. Que de trésors ne nous réserve pas encore la littérature sumérienne, elle aussi, avec ses dieux et ses héros! J'ai pensé aussi à l'aventure des Conquistadors de la Renaissance, nouvelle épopée de la latinité, avant de m'avancer vers le monde moderne, si plein, après tant d'autres, de ruines et d'espoirs. L'apaisement de la philosophie, plus que l'amère satisfaction issue parfois des revendications quotidiennes, m'a apporté la paix du cœur, l'amour vrai de la justice et le calme de l'esprit pour dominer les malheurs de ce temps.

J'ai voulu en apporter un écho au lecteur, une symphonie

poétique où la violence s'apaise pour le rythme, comme la ceinture de Marceline Desbordes-Valmore restait tout embaumée de ses roses tombées dans la mer, seul cadeau, ce parfum, qu'elle pouvait apporter encore à l'être aimé. *Ce parfum du poème à forme fixe, je le donne au lecteur, mon ami, mon frère, mon moi-même ; puisse-t-il l'accepter, en se souvenant que seul, sous cette forme, il exhale la saveur d'une des plus belles langues qui soit, la lange française, par son système propre de versification qui la distingue du vers libre, grâce aux e muets terminaux qui permettent l'alternance des rimes masculines et féminines, et aussi les règles du hiatus et de l'élision, mettant en valeur le rôle de l'i latin dont la prononciation, issue de la langue de Rome, peut aussi bien être différente de celle de la prose, diérèse ou synérèse, donnant ainsi les véritables règles de l'harmonie dans une langue pure qui a sa structure propre, qu'elle a forgé au cours des siècles, et qui ne réside pas dans l'arbitraire, fils de l'ignorance et père de l'inculture. Puisque nous sommes une fin de race, avant d'autres bouleversements, dont l'épopée sera chantée par d'autres aèdes, nous ne devons pas l'oublier ! au commencement était la poésie, et à la fin aussi. Après, il ne reste plus que des compilateurs, et des médiocres ! Saluons les premiers, nos serviteurs, et pardonnons aux autres, dont le mépris fait voir assez ce qu'ils sont, et ce que nous sommes.*

Il faut croire en soi, pour respecter le lecteur, sinon, à quoi bon ; la vieille lutte du Bien et du Mal, d'Ormuzd et d'Ahriman, d'Apollon et de Bacchus, de Dieu et de Satan, aura toujours lieu dans le cœur des hommes : ce sont eux qui décident, s'ils font un mauvais dieu, il faudra qu'un Satan triomphe, et devienne bon pour se pardonner ! Alors, à quoi bon ? Oui, à quoi bon tant de souffrance, de ruine, de mort, de menace, de mépris, d'injustice ? La vraie justice est comme l'amour, elle n'est pas inscrite dans la loi : la loi ne peut connaître que le mariage, et la réparation. La vraie justice est dans le cœur de l'homme, s'il veut ne pas

être injuste. Qu'il se rappelle qu'il communique avec autrui, avec le monde, par ses sens, antennes extérieures de son intelligence, qui lui traduisent à l'échelle humaine ce qu'il peut saisir. Le monde comme vérité et représentation n'est rien, sa quiddité nous échappe, elle est faite de toutes les quiddités dont la nôtre, individuelle, humaine, n'est qu'une partie, mais l'agnosticisme ne doit pas être une commodité pour s'endormir, pas plus que la foi une certitude pour ne plus rien chercher, seul le doute est efficace, s'il a pour outil la tolérance, ce levier qui doit soulever l'univers et déboucher enfin sur la compréhension, et non plus seulement sur la spéculation, s'il est vrai que le fétu qui nous emporte a un rôle à jouer, et d'abord si nous le voulons.

Claude COTTI.

LA COUPE DE GYPTIS

I

LA COUPE DE GYPTIS

I

Tends la coupe sacrée, ô douce jeune fille,
Et souris à la vie, au soleil, à l'amour,
Vois ! ton regard charmant, sous la belle charmille,
A subjugué le Grec, qui marchait au tambour,
Aujourd'hui, qu'on oublie où s'évade la vague,
Où s'en va la trirème au vent fort qui divague,
D'où vient que l'étranger a l'œil un peu trop vague
En voyant s'avancer ta jeunesse et ta main
Qui porte le destin comme la providence,
A l'ombre consacrée à l'accorte cadence !
Qu'il boive ! Le garçon, contre toute évidence,
A capté ton cœur pur, et son geste est humain.

II

Déjà l'on applaudit, la noce surprenante
Avec un étranger, fait s'incliner le front
Des jeunes gens soumis à la loi fascinante
De l'amour qu'on déclare en ignorant l'affront,

Simplement, librement, comme le rire inspire
Le sourire plus grave et l'appel qui soupire,
La fraîcheur qui se donne ainsi que l'on respire,
Pour fonder un foyer au rythme qui s'en va
Soutenir le désir comme la vie avance,
Comme le fier guerrier qui raffermit sa lance,
Comme l'espoir soudain qui se prend pour la chance
Et bâtit sa maison où l'enfance rêva.

III

Tel était le destin de l'antique Marseille,
Que fonda la Ligure avec le Phocéen,
En créant son foyer près de l'accorte treille
Où le Vieux Port naissait au creux marmoréen,
Site qu'un dieu sculpta comme on taille statue,
Auprès d'une colline à la pente impromptue,
Qui garde l'horizon quand le monde se tue,
Qui conserve l'espoir où s'apaise la mer,
Dont le flot blanc frémit pour lécher la calanque,
Au lointain mordoré dont le vallon se flanque,
Où la chèvre grimpa, dont le ventre s'efflanque
Près du maquis fleuri sur le ravin amer.

IV

Légende gracieuse où l'audace ensoleille
Les pas du premier Grec, le cri de l'artisan
Qui fondèrent, subtile au rivage, Marseille,
Tout cela s'effiloche ainsi que passe l'an,
Pourtant, le rythme sourd active la calanque,
Le flot déferle encore où la barque s'efflanque
Près du cargo pansu qui, superbe, la flanque,
La coupe de Gyptis anime le Vieux Port,
L'appel de Pythéas retentit à l'oreille
Pour gagner sur le Nord, loin de l'ombre vermeille,
Le pari du Midi, le pari qu'émerveille
L'espoir renouvelé sur le coquin de sort.

V

Les marins s'avançaient, leur rame sur l'épaule,
Au détour des chemins, au creux des frais vallons,
En chantonnant gaiement, en oubliant le môle
Qui connut leur départ, et l'ordre bref : « Allons ! »
Pour découvrir le monde encore dans l'enfance,

Pour surmonter la mer et mater la souffrance,
Pour s'élever plus loin que le ciel de Provence,
Ils s'avançaient assez pour qu'une fille, un vieux,
Ignorant de la mer, au coin de son village,
Pour pelle de fournil prenne la rame, ô gage,
Qui marquait la limite où s'arrête un volage
Mais fidèle à son port, à son rythme, à ses dieux.

VI

Ainsi s'en va l'espoir ; sur la mer océane,
Les colonnes d'Hercule, à l'Homme Intérieur,
Ouvrent le vaste monde, et le flot diaphane,
Hors Méditerranée emporte un autre pleur,
Les oiseaux du Tropique, ignorant de la Grèce,
Montrent le chemin neuf, toujours plus loin, oui, qu'est-ce,
Le soleil qui se lève éclaire une autre espèce,
Un autre firmament, une tempête aussi,
Différente à subir au cœur que déjà glace
L'appel de l'inconnu. Mais le Nord, dans la glace,
Pour découvrir Thulé demande encor l'audace,
Comme au Sud miroitant sous le regard transi.

VII

La voile du départ, comme le cœur de l'homme,
Se gonfle au vent d'espoir, au vent de l'horizon
Qui s'agite en grinçant pour la souffrance, en somme,
La curiosité, le désir, le frisson
Du conquérant meurtri par le soleil et l'onde,
Qui réserve au pays sa fertile faconde
Quand il reviendra fort, dans une humeur féconde,
Après tant de dangers, de tourments, de dégoût,
Pour conquérir un monde où la gloire perfide
Laisse un sillon sanglant, une trace livide,
Une larme parfois sous la chaleur avide,
Et le bras toujours fier qui commande au bagout.

VIII

Mais, plus que le grand Nord au jour hypothétique,
Sous la glace craquante où s'essouffle un blizzard,
C'est l'appel miroitant du bizarre tropique,
Où monte un reflet d'or au curieux hasard,
Qui fait du matelot l'amoureux brun du large,

Sous le sel de la mer, loin de l'accorte barge,
Loin du quai cadencé dont l'ardeur se décharge
Au clin noir du charbon près du triste derrick,
Malgré le souvenir de Pythéas superbe,
Et le flot de Thulé mûr de si glauque gerbe,
La coupe de Gyptis veut au soleil acerbe
Verser son espoir fou de chaleur pour le brick.

IX

Le miroitement lent de la mer du Tropique
Attire la légende ainsi que phare oiseau,
Quand s'allume le ciel à l'étoile typique
Et que meurt une boule en un dernier ciseau,
Chantres de l'Occident, de l'Orient qui brille,
Partout un nom s'écrit quand la plume scintille,
Inde ! qui fait briller le lourd regard que vrille
La Croix du Sud absente au noir septentrion,
La feuille qui s'en va parfois raille elle-même
Cet espoir consacré par le frisson qui sème
La poire de l'angoisse et l'espoir fou qu'on aime,
Même si l'on n'est là qu'un aimable histrion.

X

Le départ, c'est l'amour de la femme à peau brune,
Qu'on espère enlacer au rivage lointain,
Le matelot sourit en rêvant sous la lune,
Et s'endort en vibrant jusqu'au petit matin,
L'illusion sacrée est la douce maîtresse,
Commune à ceux qui vont, loin sur la mer traîtresse,
Rechercher le bonheur en fuyant la détresse,
Qui s'affale parfois au lourd pays natal,
Ailleurs, on est le fort, le héros, le corsaire,
Le plus beau, qui se plaît au môle solitaire,
En riant, à montrer au furtif adversaire,
Que la force est sa loi, son vivant piédestal.

XI

Mais l'arrivée est belle et pleine de promesse,
L'ombre frémit d'orgueil en voyant l'homme seul
Poser le pied soudain, sans qu'un fond de détresse
Marque ses traits brutaux, sans crainte du linceul,
Et la force tranquille est la loi de l'étrave,

Le bras du conquérant ne connaît pas d'entrave,
Il n'est pas le vaincu, l'indigène, l'esclave,
Il est le fier colon qui dicte au ciel sa loi,
Pour qu'un peuple courbé sache ce qu'il faut faire,
Après qu'on l'eut maté, que le moine en sa chaire
L'eut béni par la force et l'espoir de lui plaire,
Lui dont l'éperon d'or sert au pâtre d'aloi.

XII

Quand la déception montre sa soif cruelle,
Le fort, l'inconsolé, le génie incompris,
Est heureux de rentrer à l'ombre paternelle,
Vers le pays natal, plein de souvenirs pris
A l'enfance, au désir de connaître la vie,
De saisir la jeunesse, ou, quand l'obstacle obvie,
De partir pour savoir contenter son envie,
Mais jamais sans regret, jamais sans souvenirs,
Pour pouvoir murmurer, en savourant l'étape,
Le bon mot d'une mère où l'amicale tape,
Bien des saisons après, tout simplement retape,
Et sonne encor gaiement quand on peut revenir.

Mais le glabre désir...

(*Illustration de Lilia-A. Pereira da Silva*)

I

J'ai regardé longtemps la mer au reflet vague,
Dont les glauques sillons promettaient l'avenir,
J'ai humé le vent fou que l'algue fait hennir,
Et j'ai meurtri mon pied au rocher qui divague.

Pourtant, mon cœur est lourd comme est lourde la bague,
Que le doigt passe en vain au nom d'un souvenir,
Le visage charmant ne veut plus revenir,
Quand l'œil sec ne sait plus de Mémoire être drague.

L'os qui craque en marchant ne soutient plus le pas,
Le rire qui se tait efface les appas
De la vie où se meurt l'autrefois qui détonne,

Mais le glabre désir effrange dans son box
La colère impuissante où le vieillard tâtonne,
Etonné d'être moins que le massif aurochs.

II

Comme l'amer désert amoureux de la houle,
Qui porte le destin de la barque et du chef,
César désemparé, je cherche derechef,
Où s'en va l'aléa qui brille dans la foule.

Loin d'un nouveau Pharsale au visage que moule
Le vétéran pensif sur sa lame au son bref,
Je voudrais dans le ciel une nouvelle nef,
Une étoile enfin née où l'orage se coule.

La vie, en cette terre, est un furtif fragment,
L'univers est ici l'obstacle qui se ment,
Ailleurs se meut l'espoir, en un plus vaste geste.

Et notre passion est un bien pâle rêt,
Notre Dieu d'ici-bas peut-il gérer le reste
Du monde, qui s'en va sans connaître d'arrêt ?

III

Le philosophe est sage. Il a son ignorance
Pour gérer l'univers et décider d'abord.
Le temps recouvrira ce qui marqua son bord,
Où sa main s'accrocha pour nommer la Souffrance.

Il redora le monde avec la suffisance
Du pâtre qui retaille une flûte. O record !
Pan jadis a connu son lamentable accord,
Et la note partit comme la raisonnance.

Pour détailler un dieu, nous avons tant de gens,
Qu'il faut bien en sourire, et paraître indulgents ;
Nul ne sait pourtant pas si la terreur anime

Le monstre qu'on se taille ainsi qu'un soliveau,
Pour commander nos pleurs, qu'une guirlande grime
En raison. Pour génisse, un génie est un veau !

IV

Ainsi, la fin suprême, en son agnosticisme,
Est inconnue à l'homme, et dérobe au chercheur
L'objet toujours sacré de son antique ardeur,
Le reflet trop humain, ou trop vrai de cynisme.

Mais la souffrance aidant, avec le stoïcisme,
Le doute se révèle et devient promoteur,
Au nom de la Morale, il fomente un menteur,
Dont le front se redresse avec le prognathisme.

Oui, tout cela s'en va comme d'Akhénaton
La doctrine, au Soleil qui réchauffe le ton,
Le dieu du panthéisme est commode à la suite,

Le Duel, de Manès, ou de Zarathoustra,
Nous montre le désir qui miroite en sa suite,
Le Bien, comme le Mal, est un et cetera...

V

Mais les sens sont d'abord l'atout qui communique ;
L'esprit, avec le monde, ainsi pour la raison,
Peuvent se renseigner, dire leur horizon,
Sans qu'ils restent murés dans un destin unique,

S'ils veulent rechercher moins de rage punique,
Justification de la triste saison,
Mode de la conserve en morne salaison,
Pour avoir dernier mot, de colère hunnique.

Le quant à soi sordide est un fruit vénéneux,
Qui forge le respect du sourire haineux,
Il faut se souvenir que toujours l'on dépasse

La plus belle évidence au prisme le plus pur,
Il n'est que de chercher. Un soir, dans une impasse,
Tombent les Aristote et leur index trop dur.

VI

Et le monde se meut. Il existe en vitesse,
Sinon plus rien ne dure et retourne au néant,
De toute quiddité l'existence béant
Reconnaît son noumène à sa propre sveltesse.

Le mou, le dur, le pauvre ou la plus fière Altesse,
Ne sont en vérité, dans le cas échéant,
Qu'un nuage fixé, du monde bienséant,
Par force centrifuge à l'adroite prestesse.

C'est, de géométrie, en la Dimension,
Que vit l'hæccéité de cette pression,
Trois masquent le nuage au creux de cette Terre,

Jusqu'à sept on peut voir où s'en va le cosmos,
Après, la raison meurt, à moins qu'elle ne serre
Que le grand Tout furtif où s'émiette notre os.

VII

Alors, l'homme soudain se rétracte et s'insurge,
Il saisit une plume, une gouge, un pinceau,
Il est, du monde à naître, un maître encor puceau,
Mais il se prend déjà pour le vrai démiurge.

Sans ignorer pourtant, comme un pur dramaturge,
Que la gloire s'effrite où passe le rinceau,
Il veut être le dieu, hors du trou, souriceau
Qui ronge le dessert pour que reste la purge.

Il reforme un cosmos en son émotion,
Donnant volute au temps, au mot la nation,
Et, savamment nommant son immanquable courbe,

Il fomente une mode où se plaît un concept,
Qu'il transgresse aussitôt, par un geste un peu fourbe,
Pour construire une nef, ou du moins le transept.

VIII

Le Soleil, étonné de naître dans sa forme,
Eclaire un monde neuf, un monde de couleurs,
Où le noir et le blanc, tachetés de hideurs,
Voient d'un œil maculé l'ombre enfin qui s'informe.

Le pinceau d'Apollon griffe un cosmos difforme,
Bacchus, qui, pour la danse, ignore les douleurs,
Leur montre en soupirant où s'en vont les ardeurs,
Mais le ciel ambigu se cache pour la norme.

Iris, orver, sept tons, chasse le vent des Huns,
Son écharpe n'a rien des plis manichéens,
Le Bien, comme le Mal, sont beaux, dès qu'on décore

Leurs visages meurtris par les on dit en vrac,
Leurs grâces nous font signe et nous veulent encore
Le contraire de l'autre, ô guenilles en frac !

IX

L'homme croit façonner l'univers, ô comique
Dieu de création, démiurge inspiré,
Dont le ciseau ne peut, d'un geste mordoré,
Que gratter un cosmos en un refrain cynique.

Oui, ce qu'il croit créer, il le découvre, inique,
Pour se l'attribuer, d'un mirage sacré,
Mais son invention constate le créé,
Et la réalité n'a rien de sa mimique.

En découvrant le nombre, il se croit inventif,
Or, c'est un attribut de son sens primitif,
Pour lui seul il est vrai, subtil en son histoire,

L'outil pour le modèle est pris par la raison,
Raisonance d'Euclide au rite aléatoire,
Car l'espace se meut sans terrestre horizon.

X

Le dieu de l'incréé, plus que de créature,
S'inspire de héros renaissant à jamais,
Pour tous les champs de Mars, les Avrils et les Mais,
Qui sonnèrent le glas de floraison future.

Mais le bel Hyacinthe, en sa déconfiture,
Tel un Christ repentant et sage désormais,
Par manducation dit qu'il n'en pouvait mais,
Sachant sa vision rongée en la nature.

Narcisse est le plus beau de ce patriarcat,
Dont l'autocéphalie apaise un prédicat,
Et cela conduit-il à la simple prière,

Le monde, qui triomphe en sa religion,
Voit du chant créateur le rythme de trière,
Qui découvrit plus loin d'autre contagion.

XI

La coupe de Gyptis apaise le triomphe
Du héros fatigué, dont le geste vainqueur
A besoin d'un bras blanc, de la douce liqueur
D'une bouche de femme à l'émail chrysogomphe.

Pendant qu'enfin s'éteint la comète en le romphe,
Il caresse une tresse, où l'épi blond, moqueur,
Lentement s'abandonne où s'apaise son cœur,
Comme le faux bourdon, le moustique ou le gomphe.

C'est en donnant la vie, en son rythme éternel,
Qu'il est dieu, dans son corps au souvenir charnel,
Le micronucléus revit en sa cellule,

Un monde renaîtra, cet enfant pour demain
Sera le grand vainqueur, si près du mort ulule
Le duc, au doigt crochu comme une antique main.

XII

Alors, qu'importe au ciel la petite souffrance,
Le cri du condamné, du malade et de mort,
La vie est un morceau de l'univers en tort,
Qui souffrit, d'on ne sait trop de quelle attirance.

Sans respect pour les rocs de la Lune ou de France,
Ce fragment se permit de penser. Par quel sort
Pourrait-il se trouver pour être le support
D'un frisson de frisson qui supportait la transe ?

Voilà que tout est dit. Le monde comme un os
Retourne en sa farine, où germa le cosmos,
L'Instant de l'Univers est le Temps le plus vaste,

Il est le Temps, furtif en son éternité.
Eh ! ce qui n'est pas né ne peut former de caste !
La souris, pour son trou, voit l'Espace alité...

Aux murs luisant de peur...

(*Illustration de Claude Cotti*)

I

J'écoute encor le refrain d'amertume
De mon enfance aux murs luisant de peur,
Le cri de femme et du train la vapeur
Sifflant mon cœur, dont la larme se hume.

De ma terreur, qu'un hasard de bitume
A conservé pour mon front, de stupeur
J'écoute encor le refrain d'amertume
De mon enfance aux murs luisant de peur.

Le monde était solitaire, et la brume
Ne savait pas endormir de torpeur
Le mot grêlé d'un idéal trompeur,
Tout menaçant. Dans la nuit qui s'enrhume,
J'écoute encor le refrain d'amertume
De mon enfance aux murs luisant de peur.

II

Près du rempart, l'eau moite de la douve
En verdissant, reflète le passé,
D'une fenêtre, un morne trépassé
Peut-être y fut jeté sans qu'on le prouve.

Peut-être aussi, par crocs luisants la louve
Y dévora jadis quelque blessé,
Près du rempart. L'eau moite de la douve
En verdissant, reflète le passé.

Le frêle oiseau, qui, cependant, y couve,
Ignore tout de ce mortel fossé,
Le saule nain prend un air offensé
Si le passant, d'un pas furtif le trouve
Près du rempart. L'eau morte de la douve
En verdissant, reflète le passé.

III

De bon matin, je vais sur la colline,
Pour voir soudain se lever le Soleil,
Le cœur du monde est tout dans cet éveil,
Mon chagrin d'être en le voyant s'incline.

Le disque pourpre est d'allure divine,
D'Akhénaton s'efface le sommeil,
De bon matin, je vais sur la colline,
Pour voir soudain se lever le soleil.

Mon pied saignant de courage trottine,
L'appel des temps fustige mon orteil,
Je me sens prêtre en ce simple appareil
De la lumière. Apollon m'élimine
De bon matin. Je vais sur la colline,
Pour voir soudain se lever le soleil.

IV

Le soleil rouge éclaire encor la plaine,
Depuis le Temps, depuis la lune, ô mort,
Le ciel lointain oublie enfin le Sort,
Et l'horizon pense à reprendre haleine.

L'homme et son dieu, raidis de même veine,
Sous le Destin, voient le sinistre port,
Le soleil rouge éclaire encor la plaine,
Depuis le Temps, depuis la lune, ô mort !

Je n'ai plus d'âge. A pleurer larme pleine,
J'ai refroidi le lustre, et mon bras tort
Ne serre plus que le vent quand il dort.
Ne coulent plus noëls en douce laine,
Le soleil rouge éclaire encor la plaine,
Depuis le Temps, depuis la lune, ô mort !

V

Et renaîtra la nébuleuse rouge
De l'univers meurtri de son courroux,
Les dieux sont morts sur le porphyre roux,
Mais l'océan recèle un cœur qui bouge.

Le frisson glauque appelle une autre gouge,
Le nu du monde est un envol d'écrous,
Et renaîtra la nébuleuse rouge
De l'univers meurtri de son courroux.

Le nouveau Râ sera d'Ammon la vouge,
Face aux sept dieux des sens et des verrous,
Nous comprendrons un peu mieux nos grands trous,
Pour le jadis du demain de ce bouge,
Et renaîtra la nébuleuse rouge
De l'univers meurtri de son courroux.

VI

Le lent reptile au frisson morne et courbe
Sort de la vase et pond au creux du roc,
Le souvenir de la mer au noir choc
Hante son corps en un long repli fourbe.

Il sera dieu, par-dessus toute bourbe,
S'il n'est d'oiseau, de mammifère. En bloc,
Le lent reptile au frisson morne et courbe
Sort de la vase et pond au creux du roc.

Près du marais, il trace dans la tourbe
D'un doigt griffu, pour l'avenir, l'estoc
De son court membre où la marche est le troc
De la nageoire où le passé s'embourbe.
Le lent reptile au frisson morne et courbe
Sort de la vase et pond au creux du roc.

VII

Oui, ce reptile, au dos verdâtre et triste,
D'un petit astre est né. Dans le jour gris
L'intelligence, en son crâne surpris,
Fait lentement son chemin rigoriste.

En dinosaure à la trop longue liste,
Ptérodactyle et monstre. Sans mépris,
Oui, ce reptile, au dos verdâtre et triste,
D'un petit astre est né dans le jour gris.

Et l'homme vert, petit, mais réaliste,
Est un reptile intelligent, ô ris
De la nature au bizarre lambris.
Car son œuf tiède au creux du sable existe,
Oui ! Ce reptile au dos verdâtre et triste,
D'un petit astre est né dans le jour gris.

VIII

Si c'est Titan, l'astre du vert reptile
Qui, de Saturne, est une lune au loin,
Pour hiberner, dans le froid, sans témoin,
Il peut subir l'éclipse versatile.

Mais le soleil passe en saison subtile,
L'intelligence a pourvu le besoin,
Si c'est Titan, l'astre du vert reptile
Qui, de Saturne, est une lune au loin.

Car l'air épais protège l'ombre utile,
L'Homme-Serpent y mit le plus grand soin,
Il l'a puisée au gros astre en un coin,
Pour le petit, que plus rien ne mutile,
Si c'est Titan, l'astre du vert reptile
Qui, de Saturne, est une lune au loin.

IX

Je me demande où fleurit la soucoupe
Volante au ciel. S'il n'est d'illusion
L'anomalie est en l'allusion
Qui pour Titan d'air épais se recoupe.

L'intelligence, a pu, seule en sa coupe,
D'un satellite avoir intrusion,
Je me demande où fleurit la soucoupe
Volante au ciel, s'il n'est d'illusion.

Ne pouvant pas retenir l'air en poupe,
L'astéroïde en est plein ! Vision
D'un autre monde en sa révision,
Le firmament à notre port s'attroupe,
Je me demande où fleurit la soucoupe
Volante au ciel, s'il n'est d'illusion.

X

Et les vieux Grecs nommaient Titan, ô mâne,
Dans leur croyance où survit notre peur,
Un demi-dieu, non l'épaisse vapeur
De ce Titan, satellite au titane.

Sont-ils venus, jadis, par une arcane,
Les verts soldats de l'astre au flux trompeur,
Et les vieux Grecs nommaient Titan, ô mâne,
Dans leur croyance où survit notre peur

Le chef vaincu d'une escalade insane
Vers le ciel noir, vers l'Olympe en torpeur,
Oui, qu'est-ce à dire, ô mythe enveloppeur,
Qui donne un nom à tout. Quelle chicane !
Et les vieux Grecs nommaient Titan, ô mâne,
Dans leur croyance où survit notre peur.

XI

Et je revois la douve au cœur perfide
Où se mirait Mélusine en son cri,
J'entends le chant, de légende ahuri,
Près du buisson et du serpent livide.

Le vert titan qu'on hait est impavide
Depuis la pomme, ô Newton aguerri,
Et je revois la douve au cœur perfide
Où se mirait Mélusine en son cri.

Le sourd regret du serpent est morbide,
C'est une crainte, un funeste pari,
Du fond des temps, un souvenir nourri
Du premier maître, en notre cœur avide,
Et je revois la douve au cœur perfide
Où se mirait Mélusine en son cri.

XII

Le mammifère est peureux. La souffrance
Est sa déesse et forme son arroi,
Elle console et mate un désarroi,
Je l'ai subie en son antique outrance.

Puis j'ai revu, de ma petite enfance
La crainte atroce où le noir était roi.
Le mammifère est peureux, la souffrance
Est sa déesse et forme son arroi.

J'ai regretté la vieille indifférence
De la colère à la morne paroi,
Le temps sacré que le sinistre effroi
En bénissant nommait bon. Attirance !
Le mammifère est peureux, la souffrance
Est sa déesse et forme son arroi.

IV

Le cosmos toujours se regarde...

(*Illustration de Claude Cotti*)

I

Le cosmos toujours se regarde
Au rai de lumière infini,
Qui fait notre terreur hagarde,
Au ciel sous le romphe garni
De clous brillants, qu'un dieu béni
Sema jadis, belles étoiles
Loin de nous, dans le noir banni
Par Apollon qui perd ses voiles.

•

Mais le Temps, qui toujours se farde
D'ans-lumière au rythme impuni,
Garde longtemps l'ombre blafarde
De l'astre lointain, dégarni
De tout ce qu'un monde fourni
Lui donna pour vivre. Ses toiles
Ne sont pas pour ce ciel uni
Par Apollon, qui perd ses voiles.

•

Il est mort, cet astre, en sa harde
De mangeurs d'espace fini,
Quand son reflet sait par mégarde
Jusqu'à nous venir comme un i,
Car l'Espace, en catimini,
A rongé le Temps, que tu voiles,
O Chronos, nocher sans boni,
Par Apollon !... Qui perd ses voiles ?

Envoi

Dieu-Soleil au disque bruni,
Mensonge intemporel, étoiles —
— Tu le Destin, ou bien nenni,
Par Apollon qui perd ses voiles !

II

Et toujours le destin frissonne
Au rire de l'Homme, qui meurt
Et qui tue ! Un dieu lui pardonne,
Un autre se rit de ce heurt,
Un troisième maudit l'humeur
Des deux autres, car la concorde
N'est pas pour eux le vrai bonheur,
Mais la victoire, au goût de corde.

●

La volonté, déjà raisonne
Sur le panthéisme menteur,
Dont représentation sonne
Le glas, pour le bon créateur
Qui, hors de lui, fut l'armateur
D'un monde fini par l'exorde
Qui n'est pas le moi du traiteur,
Mais la victoire, au goût de corde.

●

Mais la religion couronne
Le culte qui nous vainc de peur,
Représentation qui tonne
La discipline en sa vapeur,
Loin de discussion, labeur
Pour théologien, exorde
Où ne se reconnaît prêcheur
Mais la victoire, au goût de corde.

Envoi

Sage, en ton auguste sueur,
Si veux, prends ta miséricorde,
Le passant ne maudit ton heur,
Mais la victoire, au goût de corde.

III

Mon œil cligne à l'ombre qui passe
Quand le nuage au fier soleil
Fait signe au coin noir de l'impasse
D'un orage au sinistre éveil.
Déjà le dieu rugit, pareil
A la terreur antique et belle,
Comme fut le monde en sommeil,
Quand Bacchus n'avait pas d'ombrelle.

•

Dieu de l'orage où l'homme embrasse
Sa peur au plus simple appareil,
Tu nous rappelles la main lasse
Du conquérant au dur orteil,
Qui cesse, au champ blond de méteil,
Soudain, d'allumer le rebelle.
Et s'arrête, ô frisson vermeil,
Quand Bacchus n'avait pas d'ombrelle.

•

Déesse-Soleil que harasse
Le culte d'un brusque réveil,
Sois bonne à qui ne te tracasse,
Car dans ton temple nonpareil
Se dresse, de bronze ou vermeil
Le clin d'or de l'ombre isabelle
Où s'apaisait cœur, fol ou vieil,
Quand Bacchus n'avait pas d'ombrelle.

Envoi

Front humain, de Rome ou Corbeil,
Si ton esprit plus ne libelle
Attends. Tu n'allais au Conseil,
Quand Bacchus n'avait pas d'ombrelle.

IV

Le monde qui se représente,
En soi se connaît. Il est seul.
L'intelligence est sa soupente,
Pour voir à travers son linceul.
Les sens, comme au temps de l'aïeul
Sont le seul moyen de fortune
Pour saisir un objet ligneul
Qu'un concept humain importune.

●

Le nombre de l'homme est sa pente,
A Cro-Magnon, à Saint-Acheul,
Il n'avait pas trouvé de sente
Autre. Pour dompter l'épagneul,
Roland ou Monsieur de Choiseul
N'avaient rien d'autre, sans lacune,
Français ou latin de Santeul,
Qu'un concept humain importune.

●

Il compte sur ses doigts, patente
Du corps assis sous le tilleul,
Cet homme, que son esprit rente
D'être du monde le filleul,
Pour qu'à ses pieds naisse un glaïeul,
Toute bordure sans rancune,
Hommage d'un fier bisaïeul,
Qu'un concept humain importune.

Envoi

O Vérité, l'œil de Chevreul
N'a vu que la couleur, par une
Hæccéité de trisaïeul,
Qu'un concept humain importune.

V

Je reprends ma vieille guitare,
Au rythme empuanti d'alcool,
Et la fumée est une tare
Où le vice tire au licol
La vertu, ce vieux vitriol
Qui défigure la romance
De la vie, avec son faux-col,
Que l'on a pris pour une chance.

●

Un sourire de femme, hilare
Comme un envol de parasol,
Guette ma dure barbe rare
Qui se rase au fond de mon bol,
Le souvenir d'une autre est fol,
Toujours le souvenir élance
Comme un abcès, comme un guignol,
Que l'on a pris pour une chance.

●

Et l'étoile, au ciel qui s'égare,
Me fait voir un peu de ce dol,
Qu'on nomme monde, ô rage ignare
De croyance. Où va notre sol ?
Sur la gamme il n'est de bémol
Qui ne le fixe, en l'insolence
Du sentiment, pauvre bristol
Que l'on a pris pour une chance.

Envoi

Femme, consentante ou par viol,
Si tu pleures, par ta souffrance
Ne regrette l'écu, le sol
Que l'on a pris pour une chance.

VI

Et ma ballade s'interroge
Sur le monde du sentiment,
Sur la raison, qui ne déroge
A connaître tout ce qui ment,
A savoir dorer un tourment
Pour un voisin, pour la cuisine
Du sage sous le firmament,
Dont l'œil levé rien ne devine.

•

L'homme se drape dans sa toge,
Sceptique ou bien tranquillement,
Sa fosse est la plus belle loge,
Elle est le point de ralliement,
Où s'enfonce tout argument,
Comme un dieu, qui, soudain, voisine,
Dans l'oubli, comme un nécromant,
Dont l'œil levé rien ne devine.

•

Akhénaton, mieux qu'Allobroge
Sut vaincre le Soleil. Comment
Nestorius, que Rome abroge,
D'un Christ humain fut le ciment ?
Manès a vu plus joliment
Le cathare, en sa loi divine,
Le bogomile véhément,
Dont, l'œil levé, rien ne devine !

Envoi

Bien ou Mal, illustre aliment,
De Zoroastre la doctrine,
Laissez la pomme à l'agrément
Dont, l'œil levé, rien ne devine.

VII

L'opinion du politique
Ne fait pas la bonne raison,
Elle s'efface, elle est pratique,
Comme le temps, comme prison,
La finance est un horizon
Bouché pour la valeur humaine,
Le cœur est maussade saison,
Mais l'on sait encor ce qu'il mène.

●

Le philosophe est plus caustique,
Et plus austère sa cloison,
Il est pourtant le vrai moustique
Planté sur l'ultime toison,
Mieux qu'un parti, sans trahison,
Il cherche ce qui nous promène,
L'argent est peu son oraison,
Mais l'on sait encor ce qu'il mène.

●

Le culte est une autre encaustique
Où l'habitude a sa maison,
Mais la vérité ? Rien n'indique
Le vrai Seigneur. Il est foison
De héros morts en pamoison
Pour l'Orient, la foi romaine.
Le sot préfère le gazon,
Mais l'on sait encor ce qu'il mène !

Envoi

Tolérance au trop beau blason,
Guide mon pas sans trop de haine,
J'ai baisé Nestor ! Phaéton ?
Mais l'on sait encor ce qu'il mène !

VIII

L'esthétique, en sa tolérance,
Pour l'opinion du moment,
Ne peut montrer d'indifférence
Pour le Beau, pour le vrai talent,
Celui qui, mieux que suffisant,
D'une ferveur se renouvelle,
Laissant la mode au médisant,
Pour la grâce, en courbe éternelle.

●

Tout réside dans la constance
A rechercher le mouvement,
A ne pas cacher la souffrance
Au profit d'un bon sentiment,
A ne pas bayer savamment,
Au coin des lois, quelque libelle,
Sans démonstration vraiment
Pour la grâce, en courbe éternelle.

●

Oui, foin d'une auguste sentence,
Epaisse comme un faux serment,
Sur l'Art, la sublime semence
De la main, face à son tourment
D'être l'outil que firmament
Attend pour plier ! La nouvelle
Est un peu mieux que ce qui ment
Pour la grâce, en courbe éternelle.

Envoi

Auteur, n'agis pas sagement,
Reste jeune en ta foi rebelle,
La règle ne vit pas souvent
Pour la grâce, en courbe éternelle.

IX

L'inspiration se tolère,
Devant le peuple médusé,
Si pour chanter dans la galère,
On ne se sent pas reposé.
Qu'on ne se montre pas rusé,
Mais qu'un effort généreux porte
L'auteur vrai, le jamais blasé,
Vers l'espérance, à la voix forte.

●

Que jamais, pour une colère,
On ne salisse l'épuisé,
La petite raison n'est guère
Que le coup de pied trop aisé,
Qu'un silence trop empesé
N'enterre comme feuille morte
Le débutant, au vol brisé
Vers l'espérance, à la voix forte.

●

Ne soyons pas le pauvre hère
Dont la misère est l'orgue usé,
Bavant sur l'injustice claire
Du sort, qui ne s'est avisé
De sortir l'auteur aiguisé
Qui se complaît devant sa porte
A mendier, cœur écrasé,
Vers l'espérance, à la voix forte.

Envoi

Princes, qui n'avez pas osé
M'accueillir, demain, si j'avorte,
J'irai dans mon ciel irisé
Vers l'espérance, à la voix forte.

X

Notre œil, par sept, a vu la teinte
Iriser son sens éperdu,
Par sept, la note, en son atteinte,
A son oreille a mis son dû,
Ainsi le monde s'est rendu
Au désir de l'homme, et l'écoute
Vaut l'arc-en-ciel tant attendu
Pour tirer au grand mât l'écoute.

●

Oui, le son créateur se tinte
Comme la couleur. C'est ardu,
Un nombre est pour nous la contrainte
Du savoir de l'individu,
Et, par ce concept entendu,
Il faut trouver, coûte que coûte,
Où passe le monde fondu
Pour tirer au grand mât l'écoute.

●

Le dieu, l'atome, en cette feinte,
Sont sept par l'aspect assidu,
La vérité de l'homme est sainte,
Mais autre ailleurs. Tout est vendu
Au sens, dont le chiffre est perdu,
Mais qu'on retrouve dans le doute,
Même s'il n'est qu'un nom tendu
Pour tirer au grand mât l'écoute.

Envoi

Vérité, ton malentendu
N'est qu'un outil sur notre route,
Le Vrai n'est qu'un Beau, geste indû
Pour tirer au grand mât l'écoute.

XI

La vérité de ce qu'on pense
Est inscrite, au Temps, ce rouleau
Qui ne connaît pas une transe
Mais savamment nous pousse à l'eau,
Pour garder mieux que fit Boileau
La règle d'or où vit le Nombre,
Ce dieu qui, sur son fier tableau,
Nous marque, et puis nous fait de l'ombre.

●

Il n'est pas d'abus, pas d'outrance
Qui transgresse ce beau bouleau,
A son fût notre pas s'élance,
Mais nous sommes sur un îlot
De compréhension à flot,
Rien de plus, car la branche est sombre,
Le feuillage noir, d'un sanglot,
Nous marque, et puis nous fait de l'ombre.

●

Ailleurs, le chiffre en sa relance
Est douze. Par ce nouveau lot
Son inhumanité, sa chance
Nous menace en notre goulot,
Si nous ne cherchons de falot
Que pour éclairer le décombre
D'intolérance, où le hublot
Nous marque, et puis nous fait de l'ombre.

Envoi

Apparence au pâle complot,
Ne fais pas trop, qu'en ton surnombre,
L'erreur soit là ! Ton javelot
Nous marque, et puis nous fait de l'ombre !

XII

Comme fit Socrate, à la coupe
Je bois pour narguer l'avenir,
Mais nul poison n'a fait ma soupe,
A Gyptis, à son souvenir,
Buvons, comme au vrai devenir
De la Beauté, de la Jeunesse,
De l'Espérance à regarnir
Loin du gousset de la détresse.

●

La femme que j'avais en croupe
N'est plus là pour me rajeunir,
Le front d'un enfant, de sa houppe,
Ne vient plus à ma main fournir
La caresse, et je dois bannir
L'espoir avec sa hardiesse,
Mais mon cœur a su rembrunir
Loin du gousset de la détresse.

●

Le giron où le pleur s'attroupe,
N'est qu'une niche. Il faut honnir,
La faiblesse, il n'est de chaloupe
Qui ne puisse en mer se tenir,
Il faut oser, et non punir
Le ciel, qu'imprécation blesse,
Sans chasser l'obstacle à venir
Loin du gousset de la détresse.

Envoi

Vrai dieu, si tu vis, pour finir
Ne sois pas vain, ne dis pas : qu'est-ce ?
Agoniser n'est agonir,
Loin du gousset de la détresse !

v

J'ai chanté comme Dugazon,
Croyant que le plancher est ferme...

(Illustration de Claude Cotti)

I

Doit-il finir mon horizon,
Si par hasard mon œil se ferme,
Un dieu n'a pas fait ma prison,
Doit-il finir mon horizon ?

J'ai chanté comme Dugazon,
Croyant que le plancher est ferme,
Doit-il finir, mon horizon,
Si par hasard mon œil se ferme ?

II

Et les dieux, le dieu de ce coin
De terre qui se croyait belle,
Nous font-ils mourir par besoin ?
Et les dieux, le dieu de ce coin ?

Pourquoi nous faut-il tant de soin
Pour tuer une âme rebelle,
Et les dieux, le dieu de ce coin
De terre qui se croyait belle !

III

Sur terre, est-il un paradis,
Qui console du dieu perfide,
De l'espoir perdu des jeudis,
Sur terre est-il un paradis ?

Le social, comme tu dis,
Homme, ne vaut justice. O vide,
Sur terre est-il un paradis,
Qui console du dieu perfide ?

IV

La bonté vaut mieux que la loi,
Quand le règlement nous menace
Au cœur du monde, sans emploi,
La bonté vaut mieux que la loi.

Sur le talus, sur le remploi,
La douleur du passant grimace,
La bonté vaut mieux que la loi,
Quand le règlement nous menace.

V

Il faut savoir avoir du cœur,
Le mépris n'est pas élégance.
Ce n'est qu'une acide liqueur,
Il faut savoir avoir du cœur.

On n'est jamais vraiment vainqueur
Par la haine, au nom du silence,
Il faut savoir avoir du cœur,
Le mépris n'est pas élégance.

VI

Il faut savoir aimer l'ami,
Savoir combattre l'injustice,
La raison n'est rien à demi,
Il faut savoir aimer l'ami.

Il n'est pas de bonheur parmi
L'indifférence, au cœur factice,
Il faut savoir aimer l'ami,
Savoir combattre l'injustice.

VII

Il faut savoir aimer tout court,
Aimer un sourire de femme,
Aimer l'enfant, dont le pas court,
Il faut savoir aimer tout court.

J'aime, comme le rire sourd,
Comme sourd la candeur de l'âme,
Il faut savoir aimer tout court,
Aimer un sourire de femme.

VIII

Alors, plus de religion,
De social, de beau programme,
Quand l'amour fait contagion,
Alors, plus de religion.

Le cœur vaut mieux que légion
De droits, que justice réclame,
Alors, plus de religion,
De social, de beau programme.

IX

Pourtant, la liberté, flambeau
Du monde, vainc toute amertume,
Le pendu ne veut qu'escabeau,
Pourtant la liberté-flambeau

Monte au ciel plus que le corbeau,
On aime avant tout ce qu'on hume
Pourtant, la liberté, flambeau
Du monde, vainc toute amertume.

X

Le philosophe, au monde est seul
Avec le poète, sublime,
A vaincre au-delà du linceul,
Le philosophe au monde est seul.

Mieux que chef, mieux que sage aïeul,
Quand la revanche au poing s'élime,
Le philosophe au monde est seul,
Avec le poète, sublime.

XI

Le cœur est notre vrai syndic,
La raison sagement l'écoute,
La science y trouve son hic,
Le cœur est notre vrai syndic.

Nous sommes tous du même brick,
Tirons la drisse avec l'écoute,
Le cœur est notre vrai syndic,
La raison, sagement, l'écoute.

XII

Tirons l'échelle, on est au port,
Parfois, c'est la dernière escale,
Parfois, ce n'est là qu'un report,
Tirons l'échelle, on est au port.

Qu'une déesse en son apport
Gracieux, ne me laisse en cale,
Tirons l'échelle. On est au port !
Parfois, c'est la dernière escale...

CONCLUSION

Rêve d'amour, d'espace ou de concombre...
(*Illustration de Rosa-Maria Donato*)

I

L'homme qui meurt au fond de son lit blanc,
Tout récuré de lessive dans l'ombre,
Rêve d'amour, d'espace ou de concombre,
 Blême sur son bas-flanc.

II

Ce ne sont là que souvenirs moroses
D'homme vaincu par l'espace et le temps,
Par le regret d'oublier les printemps
 Si piquants, dans les roses.

III

Nul syndicat, nul parti, nul autel,
Ne vaut l'amour que le voisin respecte,
Même sans droits, dans une cave infecte,
 Car le bonheur est tel.

IV

Oui, tous les droits réclament qu'on se porte
Bien dans son cœur, ensuite dans son corps,
Sinon, l'on hait le plus beau des records
Vers le progrès, en sorte !

V

Oui, le confort, c'est d'abord tout l'humain,
La main tendue, avant toute justice,
Le Moi content, avant l'Etat, en lice,
Sinon, le poing, demain !

VI

On le voit bien sur toute la planète,
L'expansion n'est que le songe creux,
Si trop de gens ont l'espoir malheureux,
Sans bonheur, rage honnête !

VII

Le philosophe aime-t-il sa vertu ?
Il aime aussi boire sous la charmille
Le vin d'amour, quand, tant belle est la fille,
A bouche que veux-tu...

VIII

Alors son sens imparfait de prophète,
Fait comme un dieu ce que fait l'animal
Il ne le fait, homme, ni bien ni mal,
Mais c'est sa propre fête...

IX

Il faut saisir la coupe de Gyptis,
Quand le printemps passe près de Marseille,
Quand l'horizon montre trogne vermeille
Au soleil de jadis...

X

La vieille erreur, et la vieille rancune,
Sur l'arbre creux, sur la grotte au ciel froid,
Ont trop marqué le lit d'un gîte étroit,
Sans espérance aucune.

XI

La tolérance, en aimable concept,
Est seule au monde à permettre la vie,
Non le massacre, avec sa noire envie,
Par trois comme par sept.

XII

Adieu. J'ai fait quelques pas. L'on jardine
Tout à côté. Pour combler mon oubli,
Sonnez un coup, et non pas l'hallali,
Si par Satan je dîne.

TABLE DES MATIERES

TABLE DES MATIERES

Pages

20 0207026 5

— ACHEVE D'IMPRIMER —
LE 1er AVRIL 1976
SUR LES PRESSES DE
L'IMPRIMERIE CH. CORLET
14110 CONDE-SUR-NOIREAU
———— FRANCE ————

Dépôt légal 1976/2ᵉ